Beginner's Guide to
Painting with Oil Pastels

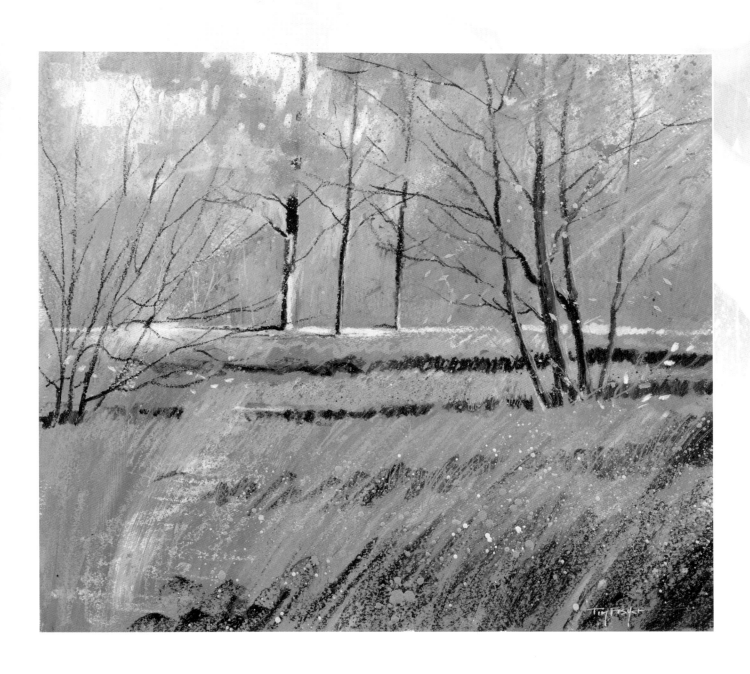

Publishers' note
You are invited to visit the author's
website at: www.timfisherartist.co.uk

Suppliers
If you have difficulty in obtaining
any of the materials and equipment
mentioned in this book, then please
visit the Search Press website for
details of suppliers:
www.searchpress.com

DEDICATION

For Louise. Thank you for your unshakable loyalty and support and
for all of your love.

ACKNOWLEDGMENTS

Thank you to Katie French for commissioning me to write this third
book for Search Press.

Thanks also to my editor, Beth Harwood, for all her help,
encouragement and feedback during the book's journey.

To my photographer, Paul Bricknell; it was again a fascinating four
days working alongside you at Search Press HQ, many thanks.

I would also like once again to thank my wife, Louise, the person
who chatted to Katie French at the 2016 Patchings Art Festival
about my displayed oil pastel painting and my long-time desire to
write an oil pastel book. At the time Louise had no idea Katie was
a commissioning editor for Search Press!

Finally, thanks to all my students past, present and future, whose
desire to learn helps to make teaching art such a fulfilling and
interesting part of my life.

Page 1
Barnsdale Wood
38 x 34.25cm (15 x 13½in)
Painted on framer's mount card.

Opposite
Lakeland Farm
22.9 x 17.8cm (9 x 7in)
Painted on oriented strand board (OSB).

Beginner's Guide to
Painting with Oil Pastels

PROJECTS, TECHNIQUES AND
INSPIRATION TO GET YOU STARTED

Tim Fisher

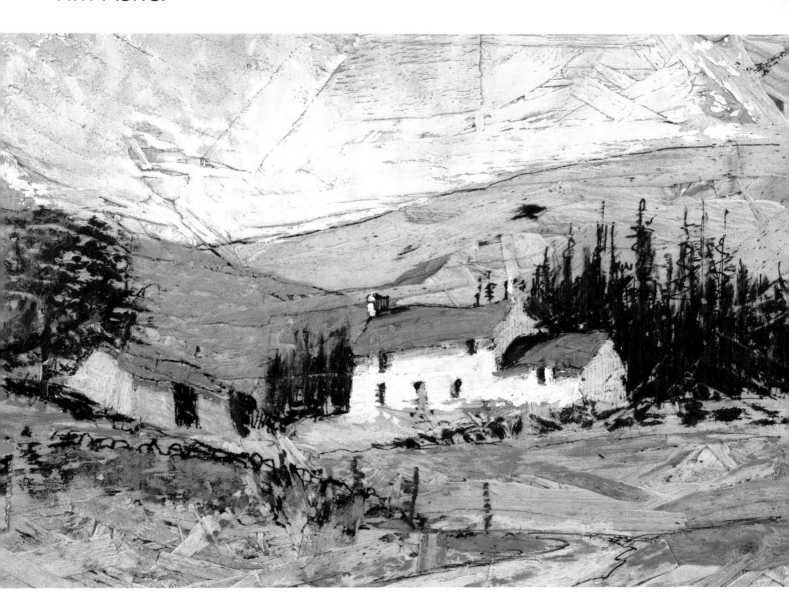

SEARCH PRESS

CONTENTS

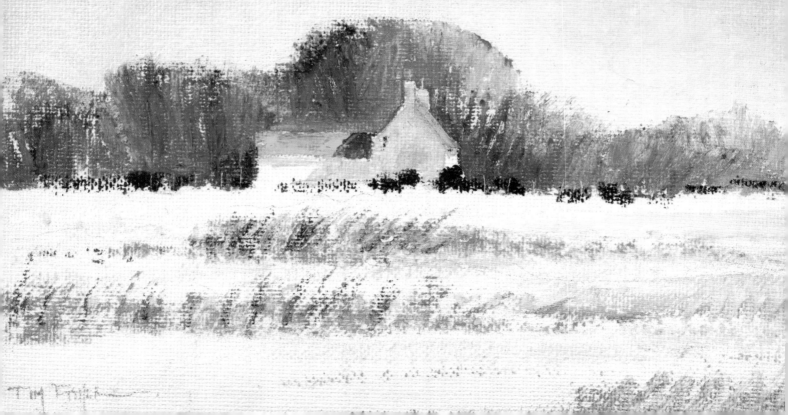

Techniques 24

Projects 44

Care and framing of your artwork 94

Norfolk Sky
*30.5 x 25.4cm
(12 x 10in)*
Painted on canvas.

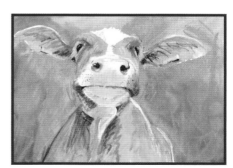

INTRODUCTION

Oil pastels are one of the most colourful and dynamic art materials available to the artist today. Favoured in the past by artists such as Pablo Picasso (1881–1973) and Henri Goetz (1909–1989), it is a mystery why they haven't been embraced by more artists. Students will often approach me on workshops and courses and say that they own a set of oil pastels that remain as yet untouched, but are unsure what to do with them. This book is designed to help the uninitiated – in easy steps – to unlock the exciting possibilities and the ways of creating new types of art that this very direct means of expression can offer.

As a relatively new medium for drawing and painting, some may be put off by associating it with other wax-based drawing instruments that they have used at school. Today's oil pastel sticks are quite different, however, and have been developed as a high-quality, professional painting tool for the serious artist.

Apples
30.5 x 22.75cm (12 x 9in)
Painted on framer's mount card (cream).

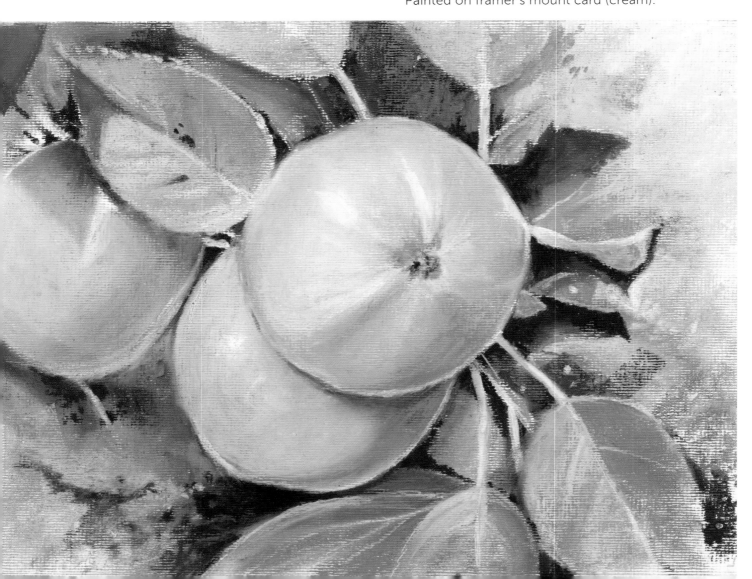

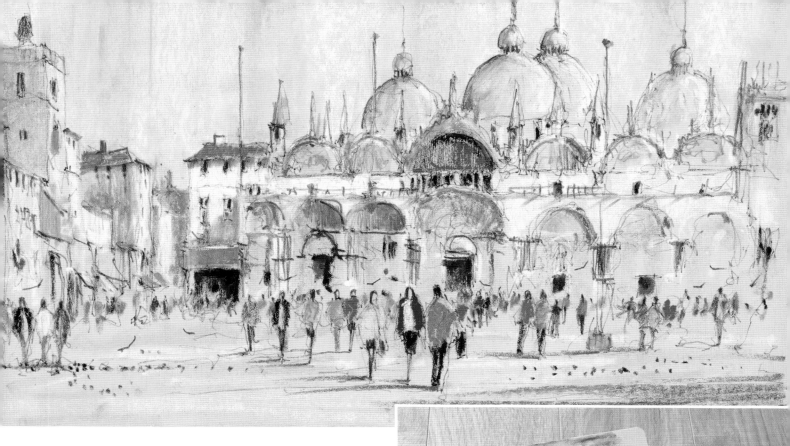

Oil pastels do not generate the dust usually associated with chalk pastels, and their colours remain bright and intense. I have been working with oil pastels for some years now, combining the practice with my love of creating sketches outdoors – these sketches can be developed quickly into oil pastel subjects back in the studio.

In the process of working with oil pastels I find myself discovering new techniques and ways of creating art that are both different and exciting. Oil pastels can be held and applied as one would work with chalk pastels, but there is so much more that can be achieved: using stencils, encaustic methods, scraping, masking and combining oil pastels with other media.

A selection of my sketchbook pages.

The other benefit of oil pastels is that they mix well with each other, which reduces the number of different colours that the artist needs to own. Oil pastels are also capable of producing art on almost any surface. When painting with oil pastels, the artist will be pleasantly surprised by the glowing colours that result, while the applied pastel remains soft and flexible, allowing changes to be made to the artwork many days later.

I hope you enjoy using this book to discover and experience new and exciting painting techniques using this art medium. During the creative journey of writing this book, I too have learned how very versatile oil pastels are, and I have endeavoured to share many of my new discoveries herein.

THE HISTORY OF OIL PASTELS

Oil pastels for artists first came into being as a result of a significant change to the Japanese education system after the First World War. For students, there was a conscious move away from traditional methods of drawing with black ink to a more colourful form of expression. It was decided that producing an improved form of wax crayon would help fill a gap that had been created.

In 1921, the Sakura Cray-Pas Company began research into manufacturing a wax crayon that was soft enough to be worked and was available in a vibrant colour range. The company experimented with combining wax crayons with the ingredients of soft pastels, which helped to eliminate dust but at the same time retained some of the properties of the chalk pastels beloved by artists. The ingredients that made up the crayon tended to limit the way it could be used: pigment concentration was poor and methods of working that we take for granted today were almost impossible.

In 1924, the wax crayon was reformulated with a new mixture of paraffin, stearic acid and coconut oil. This resulted in a softer, more blendable stick, which proved popular among students and younger artists, and which gave much more freedom of expression and design than the more expensive chalk pastels.

Until the addition of stabilizers, oil pastels were available in two varieties: 'winter' and 'summer' pastels. 'Winter' pastels contained extra oil to prevent them solidifying in cold weather, and 'summer' pastels contained less oil to prevent them melting.

Due to their cost in the early years, oil pastels did not find favour within the educational system. Instead, schools preferred to supply the cheaper coloured pencil, which was widely promoted as a means of instilling a good work ethic in children.

Despite this, oil pastels became a commercial success due to their popularity within the art establishment, and other manufacturers became keen to create a competitive product. The quality of the pastels produced was of no comparison to the professional-quality pastels we use today, and many of these new oil pastels came with severe limitations in pigment content or performance for the working artist. Nevertheless, some well-known artists of the time were persuaded to acquaint themselves – and produce artwork – with this medium. Among these artists were individuals such as Pablo Picasso and Henri Goetz. Goetz would sometimes sketch or outline his studies in oil pastel but was aware of their limitations. In 1949 Goetz approached art materials manufacturer Henri Sennelier (1906–1990) with a request for an artist's quality oil pastel for his friend Pablo Picasso. Picasso's requirement was to be able to paint freely without any technical restraints on any surface he desired – raw wood, metal, corrugated cardboard, plastic or paper – without the need for any preparation of these surfaces.

Henri Sennelier approached the problem by visualizing a solid, oil-based stick of paint from which he developed a professional fine art version. Picasso adopted this idea immediately and asked for the sticks to be produced in forty-

eight different colours. This was during Picasso's grey period, and so part of his requirement was that there should be ten shades of grey or neutral colour. The new Sennelier oil pastels were softer and superior in texture and pigment quality to earlier pastels, and were capable of producing more consistent, expressive work.

In later years, other brands of oil pastel have been produced, such as the Japanese Holbein oil pastels, and Caran d'Ache Neocolor, both of which perform well, though they are slightly less soft than the Sennelier oil pastels.

The modern oil pastels never harden and so never crack; they are acid-free and non-yellowing and are ideal for working on any surface, while at the same time providing the artist with freedom and control.

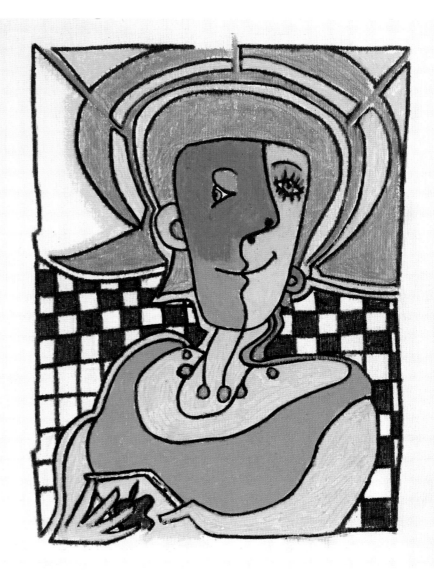

Right
Texting Muse
29.5 x 35.5cm (11½ x 14in)
Painted on fine-grain canvas glued to board.
Painted by Tim Fisher; inspired by Pablo Picasso.

MATERIALS AND TOOLS

OIL PASTELS

There is a wide range of oil pastels available to the artist, and it is easy to become overwhelmed by the sheer volume and variety. However, it shouldn't take too long to find out which oil pastels suit you best. It does no harm to keep a collection of different brands to hand, as oil pastels are all intermixable. Oil pastels that are more economical in price tend to come as harder, waxier sticks, which require considerable effort when applying and blending onto an art surface, compared to those at the higher end of the pricing scale.

The oil pastels that I prefer are Sennelier – these have a soft, creamy feel and are made from top-quality pigments held together in a pure binding medium. This combination makes them easy to blend, mix and generate new colours and textures.

Alternatively, if the Sennelier oil pastels are not readily available to you, I suggest trying the Caran D'Ache Neocolor pastels, which come in a wide range of colourfast shades. They have a soft texture that allows for easy colour mixing.

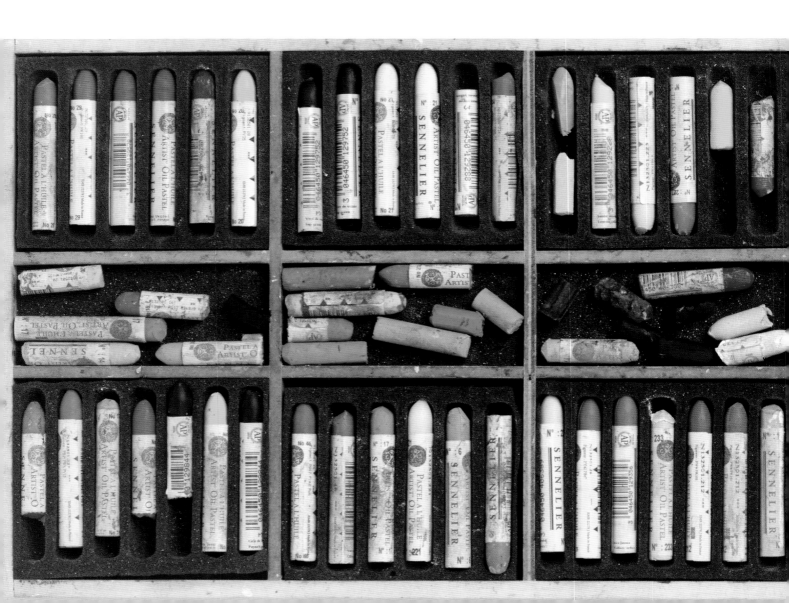

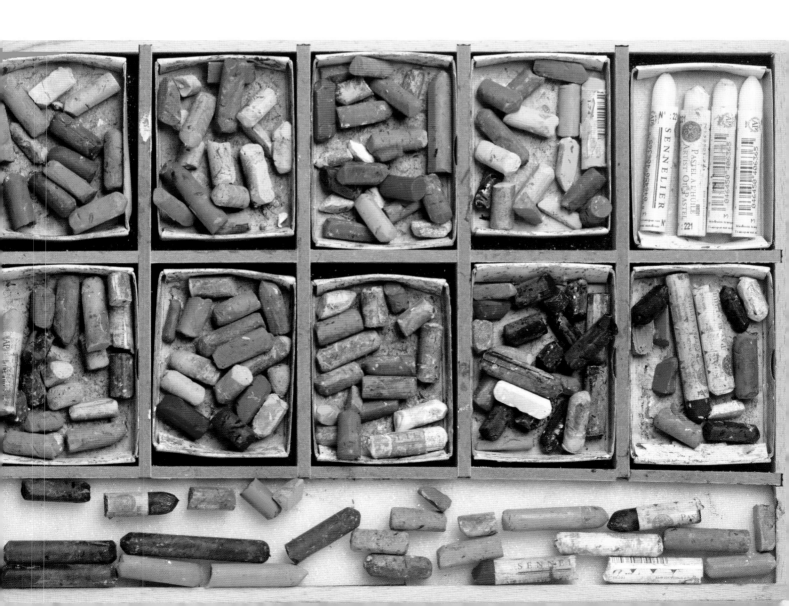

Oil pastels are completely dust-free and only a small number need to be purchased to provide the artist with a wide range of artistic techniques and colour options. The real beauty of oil pastels is that it's possible to apply them to almost any surface without preparation, making them suitable for experimentation with mixed-media work or for working over applied collage. The waxy properties of these sticks also make them ideal to be used as resists with liquid paints.

Oil pastels are usually sold in cardboard packets with foam dividers; however, I find these packets less convenient than a shallow wooden tray, which I favour. Keeping my oil pastels to hand in this way gives me more freedom when selecting and working with the vast spectrum of colours.

MY OIL PASTEL PALETTE

At the time of writing this book, the Sennelier oil pastel range consists of one hundred and twenty different colours, including ten iridescent oil pastels. Over the years I have honed down this range to a few colours that I like to use regularly. It pays to keep a smaller selection of colours, as these can be picked up instinctively as required, avoiding the need to hunt through a huge collection of sticks.

One reason why I prefer this range of oil pastels is for the unique range of greys available, which is not easy to find within other manufacturers' selections of colours. Generally, a brand's description of the colours contained within its paints or pastels are consistent; however, with oil pastel the colour description can vary from one make to another – with the exception of common pigments such as French ultramarine blue, yellow ochre or vermilion.

If you choose to use a different brand from the one I use throughout this book, then to find oil pastel equivalents can mean hours of browsing colour swatches to match up colours. However, do bear in mind that the colours that I use are invariably combined with others during the painting process; unless a colour with a similar name is substantially different from its intended shade, the difference in hue will often go unnoticed within a painting.

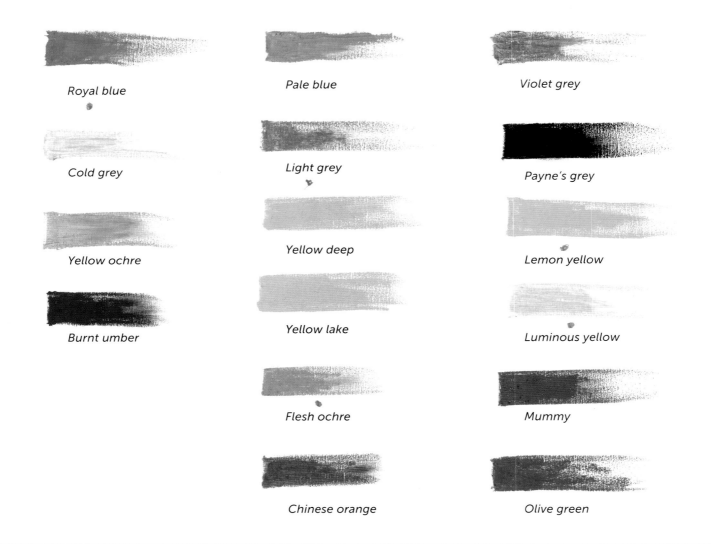

Royal blue

Pale blue

Violet grey

Cold grey

Light grey

Payne's grey

Yellow ochre

Yellow deep

Lemon yellow

Burnt umber

Yellow lake

Luminous yellow

Flesh ochre

Mummy

Chinese orange

Olive green

Beside the Seaside
28 x 16.5cm (11 x 6½in)
Painted on framer's mount card.

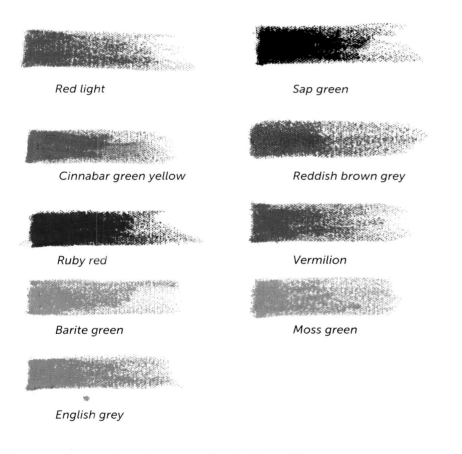

Red light

Sap green

Cinnabar green yellow

Reddish brown grey

Ruby red

Vermilion

Barite green

Moss green

English grey

These two pages show just a small selection of the oil pastel colours I use – any additional colours that feature later in this book are listed with the projects in which they appear.

ADDITIONAL MATERIALS AND TOOLS

Any tool that helps to make the oil pastel painting process easier or your work more creative is well worth having. Over the years I have amassed quite an eclectic collection of items that come in really useful when working on a painting.

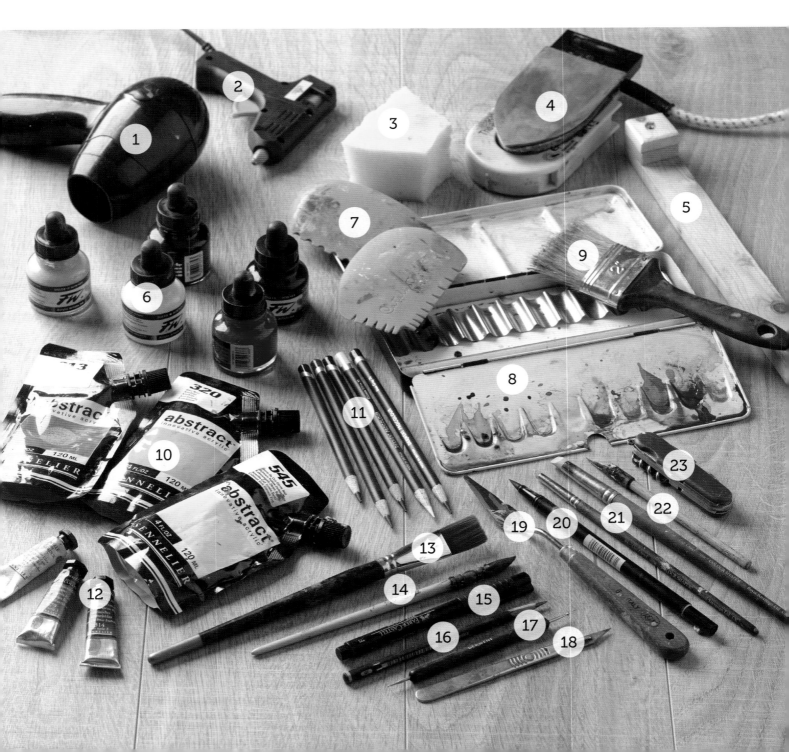

Opposite
Scalpel, cutting mat and tracing paper
The cutting mat protects surfaces from damage, while the tracing paper can be used to transfer designs for cutting and embossing.

Right
Ice packs
In warm weather, ice packs prevent oil pastels melting and digging into the painting surface. I use a box lined with foil into which I put ice packs. The shallow pastel trays fit on top, and the ice packs beneath chill down the oil pastels for later use.

1 Hairdryer A hairdryer is useful for warming up the surface of a cold painting, to make oil pastels easier to blend, or even for completely melting sticks for encaustic work.

2 Hot-melt glue gun Secures pastels to the painting surface and stops them being blown away when using the hairdryer.

3 Sponge A section from a larger synthetic sponge, ideal for applying melted oil pastel to a painting.

4 Encaustic iron or hot plate For melting oil pastel sticks (see page 27).

5 Homemade mahlstick To bridge the painting and to keep your hands clear of the painting surface.

6 Acrylic inks Ideal for resists where strong colourful washes are required; or for drawing using the steel nib dip pen.

7 Silicone catalyst contour blades Different designs for adding texture into wet applied acrylic paint.

8 Watercolour paint palette For organizing and mixing your paints,

9 Harris 5cm (2in) bristle brush with some bristles removed. For flicking dissolved oil pastel onto the painting surface.

10 Acrylic paints Applied as initial coats before adding oil pastel. Textures can be created while paint is still wet.

11 Colouring pencils When kept sharp, these are ideal for adding fine detail such as hairs on animal portraits or rigging on boats.

12 Watercolour paints For subtle coloured resist washes when applied over oil pastel.

13 2cm (¾in) nylon flat brush For producing a wide variety of acrylic paint strokes.

14 Squirrel brush This soft brush will glide easily over applied oil pastel without picking up any pigment when applying resist washes with watercolour.

15 Faber-Castell Pitt artist pen The fine-point version of this instrument can be used on a variety of surfaces to create an ink drawing prior to applying oil pastel.

16 3B pencil For creating drawings on surfaces such as pastelmat paper or canvas.

17 Stylus For embossing designs onto softer surfaces before applying oil pastel over the top (see page 27).

18 Scalpel For cutting out masks in thin paper. The fine blade of this smaller instrument allows for more precision and curved cuts if necessary.

19 Small palette knife For manipulating oil pastel on the painting surface or for scraping off and applying from oil pastel sticks.

20 Tombow pen with flexible brush tip. Ideal for working on gessoed board, as in the *Street Scenes: Venice* project on pages 60–68.

21 Colour shapers, sizes 2 and 6 cup, chisel-firm These soft, heat-resistant silicone instruments are available in a range of shapes and sizes that can be used to create texture and mix colours by manipulating the oil pastel surface.

22 Steel nib dip pen A drawing instrument that creates interesting and expressive line work. Ideal for working on surfaces such as oriented strand board (OSB – see pages 16–17) on which it would be difficult to use a fibre-tipped pen.

23 Penknife For scraping back layers of oil pastel to reveal the surface beneath.

SURFACES

Surfaces, from left to right:
Clairefontaine pastelmat paper in
sienna; line and wash board; framer's
mount card; gessoed hardboard; mount
card treated with texture paste; line and
wash board; aluminium; Clairefontaine
pastelmat paper in light grey.

Some subjects, when represented in oil pastel, can
present challenges – such as applying the fine detail
of ropes and rigging or other paraphernalia. Surface
selection is important where these types of effects need
to be achieved. If a different, more abstract, finish is
required then this should be considered when selecting
the best surface to work on.

Papers designed specifically for soft pastels work well
as the tooth allows multi-layering, blending and deep,
rich colour. Smoother surfaces allow for fine detail to
be created through scraping back, stencilling or drawing
fine lines into the oil pastel.

Oil pastels are designed to work on many different
types of surfaces or grounds. The oil pastel's behaviour
is almost always different depending on your choice,
which results in new and exciting ways of working with
this medium.

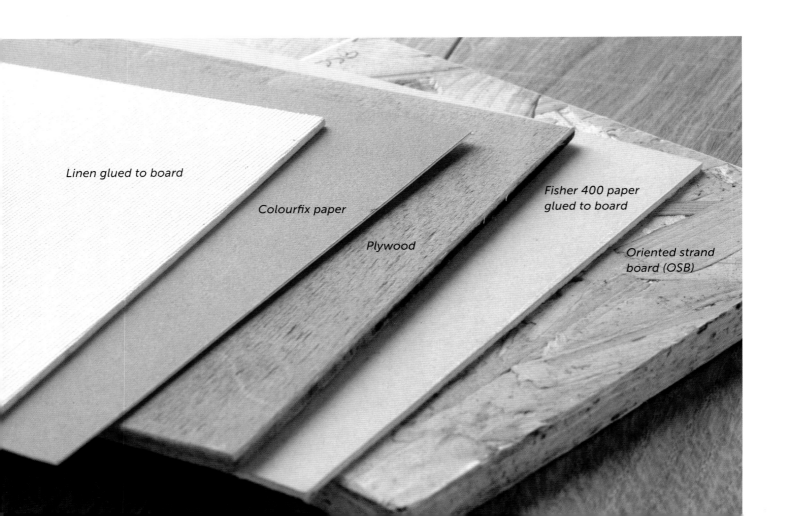

Linen glued to board

Colourfix paper

Plywood

*Fisher 400 paper
glued to board*

*Oriented strand
board (OSB)*

The beauty of oil pastels is that they can be applied to almost any surface, including glass. Here is a selection of my favourite surfaces:

Framer's mount card Usually the discarded remnants from the process of cutting picture frames, these handy pieces of card are usually my first choice of surface when creating a painting. Working on the white reverse side of the card, ink lines can be created to work to. Oil pastel scrapes back easily to reveal the white ground. Alternatively, coloured grounds can be created. Occasionally I prefer to use acrylic, sometimes with a coarse brush or grooved scrapers to generate texture prior to the application of the oil pastel.

Mount card coated with pastel ground primer (shown on page 18) provides a non-absorbent surface with additional tooth, which is ideal for oil pastel work.

Line and wash board I prefer the firmer board surface to sheets of watercolour paper. Line and wash board is usually fairly smooth with a slight Not (textured) surface which is ideal for laying down watercolour washes for an underpainting, or for working in mixed media. The surface is slightly absorbent, soaking up some of the oil from the pastel, thus making it easier to apply further layers.

Clairefontaine pastelmat paper Oil pastel behaves quite differently on this surface compared with the mount card and the line and wash board: I think the main difference is working on absorbent and non-absorbent surfaces – the non-absorbent surface being easier to blend and manipulate pastel on. This non-absorbent surface also comes in a wide selection of colours, adding another dimension for the oil pastel painter.

Fisher 400 art paper This surface has quite an aggressive tooth or texture, and pastel quickly gets eaten up. However, the finished painting can have a rich, oil painting quality to it. Interesting effects can be achieved by pre-wetting the surface of this art paper with a solvent – such as distilled turpentine – before applying the oil pastel.

Plywood Normally plywood would require priming before being painted on, but with oil pastels, paintings can be worked up and developed directly onto the surface. The natural wood colour and wood-grain texture of the background helps enhance any finished painting.

Canvas A medium- to fine-grain canvas works well with this medium: pastels will mix and blend easily for interesting effects. The texture of the canvas weave gives a better grip to the oil pastel when it is pulled across the surface and allows for multiple layering. Solvents such as those that improve flow and drying times in oil paints can also be used to create the effect of an oil painting.

Primed hardboard Adding a surface primer such as an acrylic gesso, provides a white, waterproof surface on which to apply oil pastel. The surface can be sanded between coats or left with the brushstrokes on which helps to add texture to the painting.

Oriented strand board (OSB) This is a coarse, heavily-textured surface where parts can be left unpainted to show through the original work and form part of the finished painting.

Colourfix paper This has a gritty coating, and comes in a wide range of colours. The non-absorbent surface takes oil pastel well with easy blending. Line work using coloured pencil shows up well when drawn over the oil pastel.

Aluminium panel An aluminium panel makes a good lightweight, rigid, warp-free painting surface. Oil pastels can be painted directly onto bare metal panels: scraping back the pigment can create some interesting effects. No other medium will adhere to the bare surface.

Some panels come with a protective plastic sheet which should be peeled off before use. If you need to clean the surface then a solvent and rag can be used.

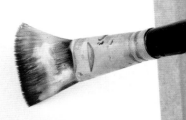

SURFACE PREPARATION

Prior to starting an oil pastel painting, it's worth considering the type of preparation that needs to be carried out. Some methods just add colour whereas others introduce texture, grip and surface sealing.

Coating a surface with grip coating.

GRIP COATING

To prepare your surface with a grip coating that will help adhere the oil pastels to the chosen surface, use an acrylic primer such as pastel ground. Dilute 2–3tsp acrylic primer with a sprinkling of water. Stir the acrylic primer and the water together with a small palette knife. Then, using a 2cm (¾in) flat brush, check the mixture's consistency and keep stirring – once your mixture has reached the consistency of single cream, paint the diluted acrylic primer over your work surface.

WATERCOLOUR WASH

Creating an underpainting of subtle watercolour is ideal for later work with oil pastels. This method is fairly limited to use on watercolour paper with a weight of approximately 300gsm (140lb) although I also enjoy working on line and wash board, which provides a firm painting surface. Mix two red and yellow watercolours, such as quinacridone red with Sennelier yellow light. Keep a blue – such as French ultramarine blue – separate to avoid making the wash green or grey.

 In the exercise below, I have used a 2cm (¾in) flat brush to apply the watercolour.

1 Tilt the board. Start with a dilute wash of yellow, then introduce red. Allow the colours to fuse together. Introduce blue, then repeat the sequence as you move down the board.

2 Progress to the foot of the paper, avoiding muddy colours by rinsing the brush between strokes.

3 Leave the board at an angle so that the paint can settle and dry.

ACRYLIC WASH

Acrylic paint can be applied to a range of art surfaces – including framer's mount card, as shown below.

As acrylic paint is a thicker medium, texture can be introduced with loaded brushstrokes or with texture tools. Try not to dilute the paint with water too much as you will lose the benefit of suggesting texture. The acrylic colours used for the simple grass backgrounds below are azure blue, cadmium red light hue, burnt sienna and cadmium yellow light.

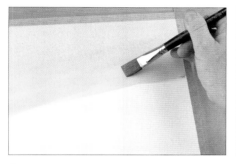

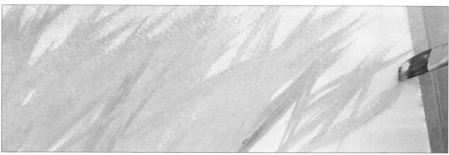

1 Start with a wash of azure blue on its own: this should be quite a dilute wash, swept horizontally across the mount card using a 2cm (¾n) flat brush.

2 Mix cadmium yellow light with azure blue and paint over the top of the blue wash. Apply the colour quite thickly, in streaks, to dry as solids so that the application of oil pastel will create texture. Sweep in the cadmium red light hue at the bottom as well. Then use burnt sienna to darken the green at the bottom.

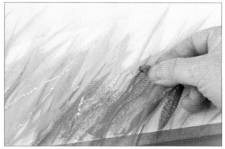

3 Sweep two different-shaped catalyst tools (see pages 14–15) upwards through the acrylic paint to plough grooves and create an uneven – almost embossed – surface.

4 While the paint surface is still wet, scrape through the paint with the tip of a penknife. The knife abrades the surface so that the damp mount card breaks up and creates more texture. Let the paint dry and harden.

5 Sweep in some more grasses, this time using an olive green oil pastel over the top of the textured acrylic wash.

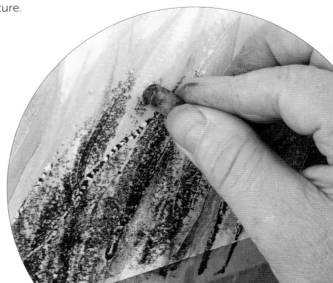

6 Finally, go over the olive green grasses with a sap green oil pastel. The grooves made by the catalyst tools and the penknife will show through the pastel.

GETTING STARTED

In this first oil pastel painting project, you will learn how to make some basic marks with your oil pastel, and layer and blend colour to give a realistic effect to your work. Finger-blending helps to push the oil pastel into your painting surface. For this project, the canvas surface is quite coarse, so the blending process helps to ingrain the colour into the canvas.

YOU WILL NEED:

Surface: stretched canvas

Tools: colour shaper (size 6); scalpel; wet wipes (baby wipes)

Pastel colours: ruby red; vermilion; royal blue; Chinese orange; olive green; yellow ochre; white; Payne's grey

PAINTING A RED PEPPER

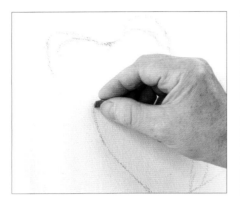

1 Draw in the main shape of the pepper with the ruby red pastel.

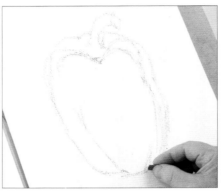

2 Detail the shape of the pepper with the pastel – specifically the curves and the stalk.

> **Tip**
>
> Work the whole outline of your painting in a single colour: you can go over it in different colours at a later stage.

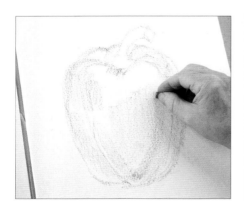

3 Begin to block in some different red shades within your outline, beginning with vermilion. Leave some distinctive areas of white for highlights, especially on the top-front edge of the pepper.

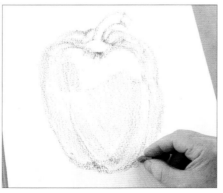

4 Go in with the royal blue pastel for darker tones around the stalk; go into the shadow areas around the curves of the pepper and into the base.

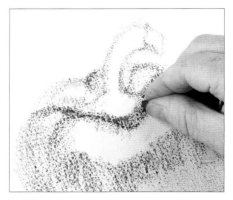

5 With the ruby red, reinforce some of the darker areas over the top of the pepper and the edges to define the curves of the pepper.

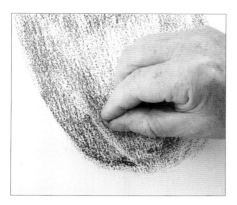
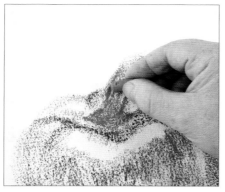
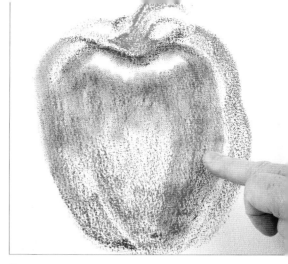

6 Sweep in some Chinese orange (a reddy-orange) over the edges of the pepper.

7 With the olive green, block in the colour of the stalk.

8 Use a finger to blend the colours. This helps to push the oil pastel into the base of the canvas. Work around the shape of the pepper, applying quite a lot of pressure. Keep some areas clear and use the white of the canvas to suggest highlights.

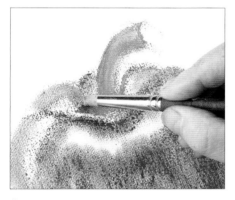
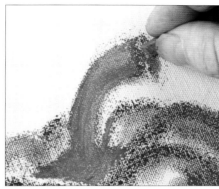

Tip

Before finger-blending, it is best to wipe your hands with wet wipes (baby wipes).

9 Use a size 6 colour shaper to blend into the tighter areas of the pepper and work with more precision. Push the green of the stalk into the red areas of the top of the pepper to modify the stalk's shape.

10 Add a dash of yellow ochre into the tip of the stalk.

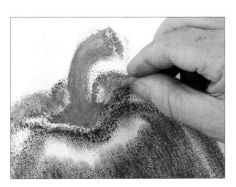
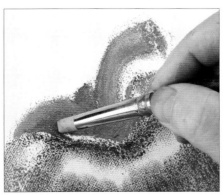
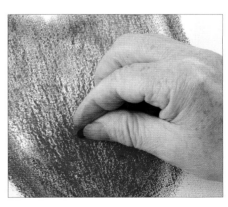

11 Start to layer the colours that make up the pepper, starting with the Chinese orange. Work off the tip, rather than the side, of the pastel to push more colour into the canvas surface.

12 Push the colour in, using the colour shaper.

13 Take up the ruby red again and block in the right-hand side and front edge of the pepper to create a solid area of colour.

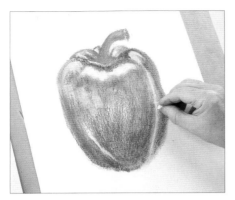

14 Use the white pastel to recover some of the highlight areas, especially down the edges of the curves of the pepper.

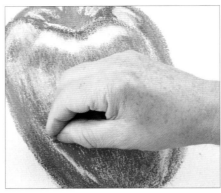

15 Go back over the solid areas with the Chinese orange pastel, then the ruby red and vermilion oil pastels. Use the ruby red to further redefine the pepper's edges.

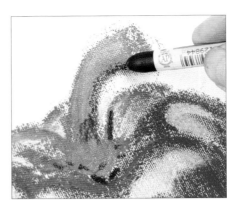

16 Use Payne's grey to fill in the shadows coming up from the base of the pepper and around the stalk, as well as around the shape of the stalk itself.

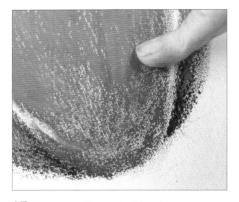

17 Use your finger to blend the shadows.

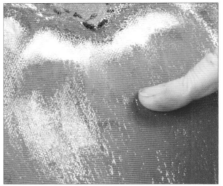

18 Then blend the red back into the canvas surface to create a smooth effect.

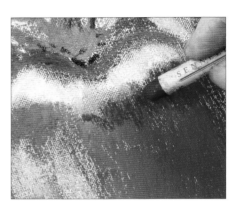

19 With the ruby red, redefine the shape of the front of the pepper, and blend the red downwards with your finger.

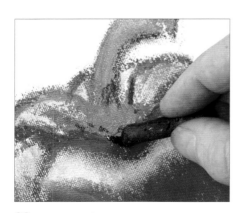

20 Use Payne's grey to push darker colour in under the stalk.

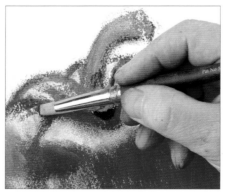

21 Blend the darker colour into the top of the pepper using the colour shaper, for a softer blended effect.

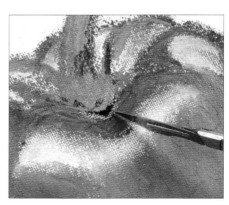

22 Finally, use a sharp scalpel to scratch out, and recover, some of the highlights for a sharp edge around the base of the stalk and between the topmost curves of the pepper.

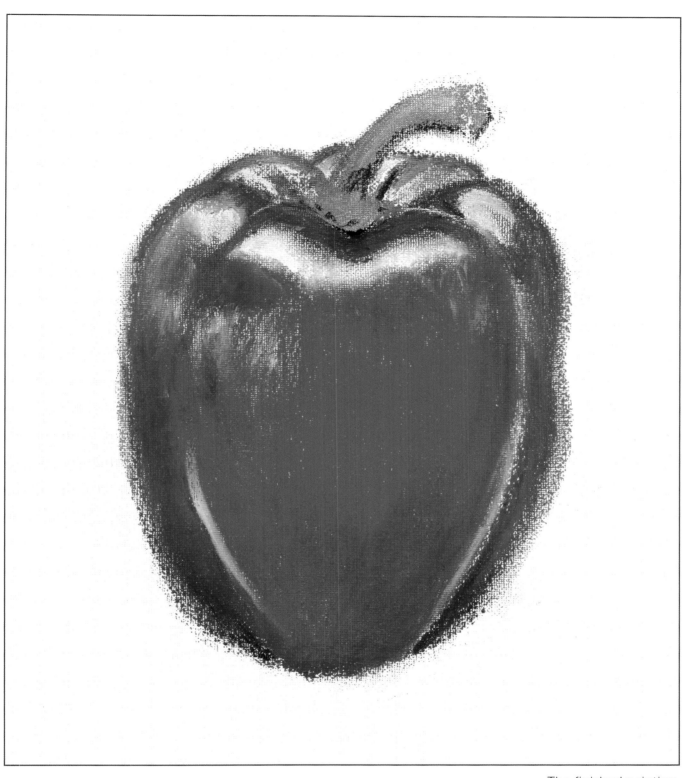

The finished painting.

TECHNIQUES

MARK-MAKING

One of the most appealing qualities of oil pastels is their versatility in mark-making. On these pages I demonstrate nine of the many different marks and impressions that you can make using your oil pastels alongside one or two additional artists' tools.

1 The side stroke: flat
Hold your pastel horizontally against the surface and pull downwards. Applying more pressure gives a stronger mark.

2 The side stroke: narrow
Hold your pastel vertically against the surface and pull it downwards to make a thin, linear stroke.

Note

Getting a good, flat stroke can be tricky and dependent on a number of factors, such as the surface texture. Allowing the oil pastel to get too warm can also result in it digging in and creating an uneven surface.

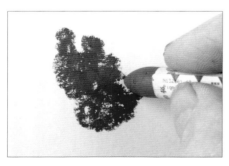

3 Scribbling
The tip of an unwrapped oil pastel can be used to draw with and to build up the structure of a painting before applying multiple layers.

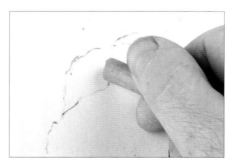

4 Rolling
Rotating the oil pastel between your fingers as the line is drawn can produce interesting marks and effects.

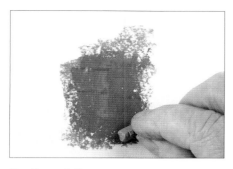

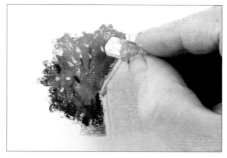

5 Scumbling

Drag the side of a pastel over a preworked textured surface so that elements of the underpainting can be seen.

6 Dashing

This is a technique often used towards the end of a painting: stab at the surface with the oil pastel to force more pigment onto the surface. This technique is useful for creating sky holes in trees.

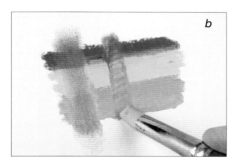

a

b

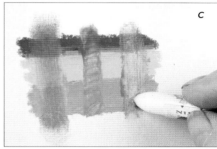

c

7 Blending

For gradual gradations and subtle colour changes, rub at the marks made by oil pastels with your fingertips or a blending tool. The photographs above show three blending techniques:

a) Blending with your fingers.
b) Blending with a colour shaper
c) Blending with a transparent pastel made with wax and oil (no pigment).

Note

Some brands of oil pastel are too hard to blend with your fingers; sometimes a rag is required.

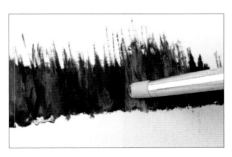

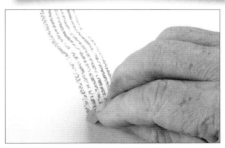

8 Mashing

When a large amount of oil pastel in different colours is applied to a surface it can be manipulated and formed – or mashed – into different shapes using a blending tool, such as a colour shaper.

9 Notching

By adding notches and grooves to the oil pastel using a scalpel, you can achieve different effects with the marks that you make – such as wood-grain textures. Cheaper, harder pastels work better for this technique as the rate of wear is slower.

SPECIAL EFFECTS

Various techniques can be employed to create a range of effects that are unique to the oil pastel medium. These are limited only by the artist's imagination. Below are just a few special effects I have discovered.

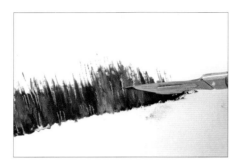

1 Scraping back (*sgraffito*)

On white, non-absorbent surfaces it is possible to scrape back through the oil pastel to the original surface using a scalpel. Alternatively, heavy colour can be applied, over which dark pastel is applied, then the surface can be scraped back to reveal the underlying colour. This method is often referred to as *sgraffito* (see pages 28–29).

2 Palette knife strokes

Oil pastel can be applied to a surface with a palette knife; however, this is only usually successful with softer oil pastels.

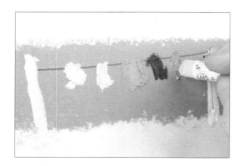

3 Masking and stencilling

This method saves a lot of time as almost instant detail can be added to a painting by cutting out stencils or using the edge of a sheet of paper to create a sharp edge (see pages 30–31).

4 Using solvents

By using solvents – from alkyd-based flow and drying aids to turpentine – oil pastel can be dissolved on a palette and painted on to a surface like an oil paint. Alternatively, the solvent can be applied to the surface first and then drawn into (see pages 34–35).

5 Embossing

On softer surfaces an impression can be made in the paper using a cocktail stick or, in this case, a metal stylus. This mark remains after oil pastel has been worked over. The method can be used for grasses, fur or other effects where a fine line is required. Working through tracing paper is a handy way of keeping track of your design on the paper.

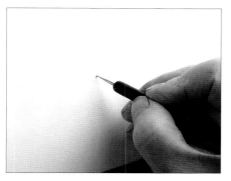

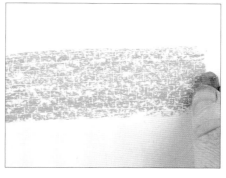

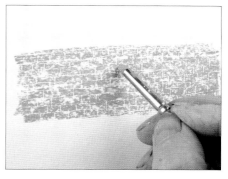

1 Scratch into your surface using a stylus. This is best done under a raking light (a bright light source from an oblique angle) so you can see where you've already drawn. For this exercise I've scratched in the bricks of a wall.

2 Pull the oil pastel over the embossed area to reveal the underlying drawing.

3 Use a colour shaper to push the pigment into the surface.

6 Encaustic effects – sponging and spattering

These can be achieved in a number of ways: oil pastel can be melted onto an iron plate, then picked up and applied with a sponge or a palette knife, or flicked onto a surface as spatter with a household paintbrush as shown below.

Tip

Your oil pastel can also be glued to a surface and heated with a hairdryer to create runs and dribbles (see page 33).

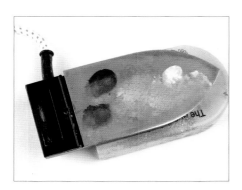

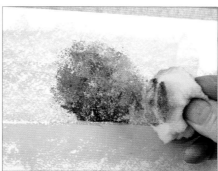

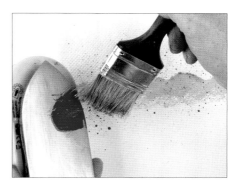

1 Melt your oil pastel on the base of an encaustic iron.

2a Dab the melted oil pastel onto your painting with a piece of sponge...

2b ...or use an old household paintbrush with some of its bristles cut out to flick the colour onto your flat surface. This technique is used within the *Flowers: Poppy Field* project, on page 48.

SCRAPING BACK (*SGRAFFITO*)

Sgraffito can be used to create simple or more elaborate designs by scraping back to reveal the underlying colour, which may have been applied previously with acrylic or watercolour.

Create your painting on the coloured side of framer's mount card as this works well as a unifying base colour.

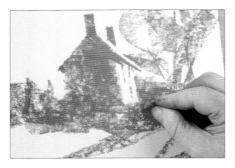

1 Begin by using a red light oil pastel to create the shape of a house and some surrounding foliage.

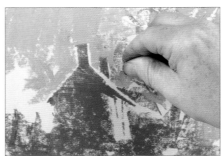

2 Fill in the sky around the outside of the house with a pale blue oil pastel.

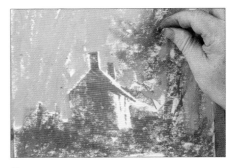

3 Fill in the foliage on both sides of the house, and in the background, with an olive green pastel.

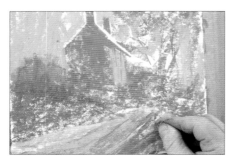

4 Go over the foreground path and the side of the cottage (the windows) with yellow ochre.

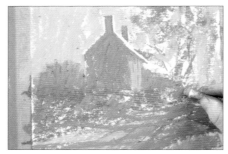

5 Scribble over the red areas of the cottage using a violet grey oil pastel – use this colour to fill in some shadow areas.

6 Fill in any gaps in the sky using a pale blue pastel.

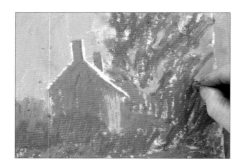

7 Scribble in more red light around the cottage, and work this colour into the background foliage. Scribble in a little extra violet grey to square off the cottage.

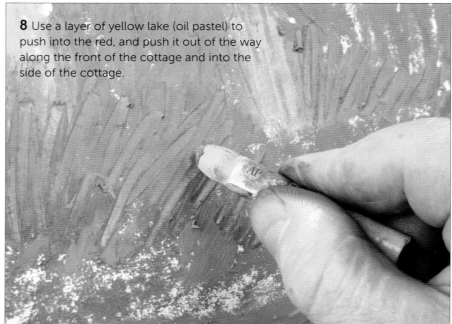

8 Use a layer of yellow lake (oil pastel) to push into the red, and push it out of the way along the front of the cottage and into the side of the cottage.

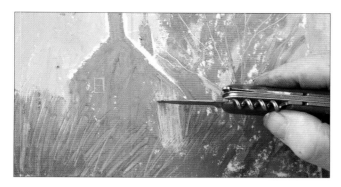

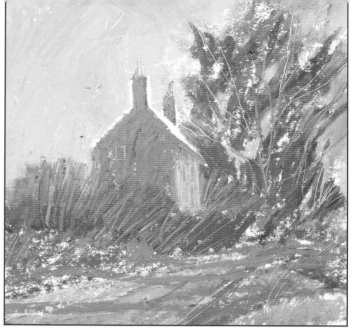

9 Apply the *sgraffito* effect with the tip of a penknife – make diagonal strokes as you remove the top layer of oil pastel to reveal the colours beneath. Scratch up the tree on the right of the scene using longer, taller strokes. Then come down into the track, and make long, radiating scratches down towards the bottom of the mount card, to complete.

The finished exercise.

MAKING A SCRATCH CARD

A scratch card can be made by applying a heavy layer of oil pastel to a smooth surface, then painting over with a black acrylic ink. To keep the ink soft and workable, a small amount of detergent is added before applying the ink, at a ratio of 30:70 (thirty per cent detergent to seventy per cent ink).

Begin by filling your board or mount card with bright colours for the underpainting – here, I have used oil pastels in royal blue, yellow lake, red light, English grey and bright yellow.

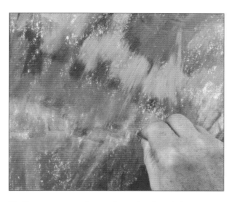

1 Cover your board entirely with a thick layer of colour, using the oil pastels.

2 Pour a small amount of detergent into a pot of black acrylic ink.

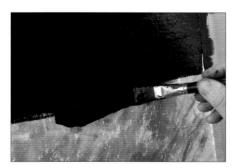

3 Stir the ink, then using a flat nylon brush, apply the dilute ink from left to right, top to bottom over the oil pastel layer. Make sure the brush is flooded with ink, otherwise the brush will stick to the underlying oil pastel layer. Leave the acrylic layer to dry (this can take up to twenty-four hours).

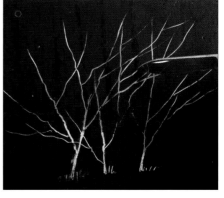

4 Scratch out an image using a sharp knife such as a penknife – the colour of the oil pastels below will shine through.

MASKING AND STENCILLING

Making precise marks with oil pastel can be challenging. Stencilling with 90gsm (60lb) printer paper offers a means of adding elements of detail into a subject, or of masking off areas to create straight edges – such as to extend the headland in the yachting scene, below.

To form a straight edge, hold a sheet of paper across your painting and use it to mask off the area below your intended straight line.

YACHTS ON THE HORIZON

1 Draw in your two opposing headlands first – the left-hand headland in the mummy shade of oil pastel, the right in violet grey – above your paper mask.

2 Draw your oil pastel from left to right, not up and down. Lower the paper, then extend the headland on the right of the scene.

3 Pull away the masking paper to reveal your straight edge.

4 Lay in a loose, pale blue side stroke to represent water. Use a similar colour to the blue you have used in the sky.

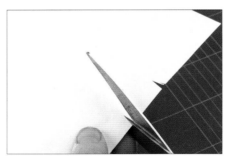

5 Cut out some sail shapes from the masking paper. These can be tiny to represent distant sails.

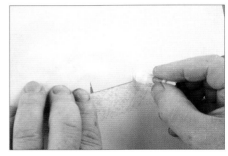

6 Apply the oil pastel – here, white – through the stencil to form the sails.

7 Lift up the stencil paper again, this time to reveal the subtle sail shapes set against the land. At this stage, you can add more, smaller sails in the distance.

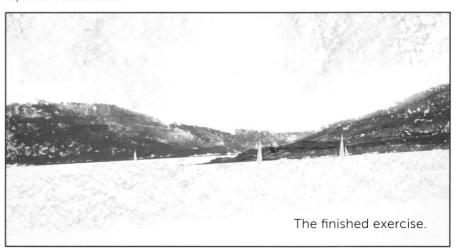

The finished exercise.

The process below uses shapes that are cut out of tracing paper and overlaid on the oil pastel as stencils. This is the same technique that I've used at steps 41–43 of *Staithes Cottages*, on pages 70–77.

Tip

Keep the shapes of your stencils simple.

THE WASHING LINE

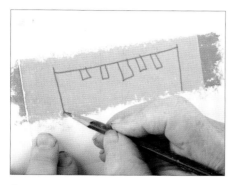

1 Draw your stencil shapes on a scrap of tracing paper over the top of a layer of oil pastel, using a pencil.

2 You will leave an impression of your pencil drawing on the oil pastel.

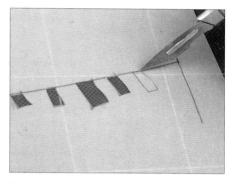

3 Cut out the shapes using a scalpel on a cutting mat.

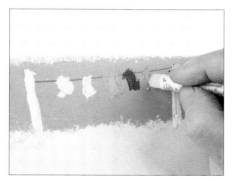

4 Place the tracing-paper stencil back on the surface using the original pencil marks to line it up, and stab through the voids with the oil pastels.

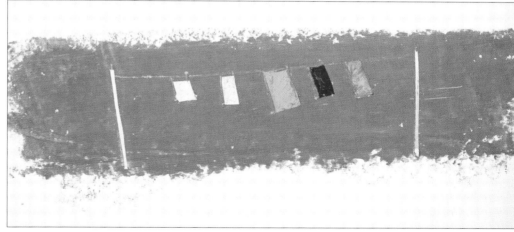

5 Remove the tracing paper to reveal your stencilled shapes.

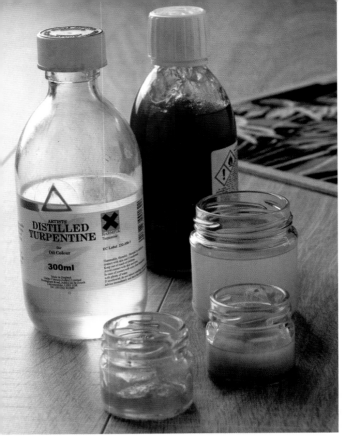

USING SOLVENTS

Dissolving oil pastels is another way of generating techniques and ideas from this versatile medium. Oil pastel will soften easily in a wide range of solvents although some of those not designed for art use can produce unpleasant odours. Oil painting alkyd mediums will dissolve oil pastel easily and turn the sticks into a solution that can be blended and painted with a brush. Distilled turpentine has a strong smell but is a good solvent; alternatively, odourless thinner works well.

When heat is applied, oil pastels will melt and this can be used for a variety of effects, such as blowing with a hairdryer or flicking specks onto the surface with a bristle brush.

Left
Solvents, including distilled turpentine, Sennelier Fluid 'n' Dry (alkyd resin medium), odourless thinner, decanted turpentine, decanted alkyd resin.

Below
A Norfolk Village

33 x 22.75cm (13 x 9in)

Painted on Fisher 400 art paper (sanded).
In this painting, turpentine was applied after an initial application of oil pastel, to encourage the pigment to sink into the base of the paper, re-releasing the tooth to allow further layers to be added.

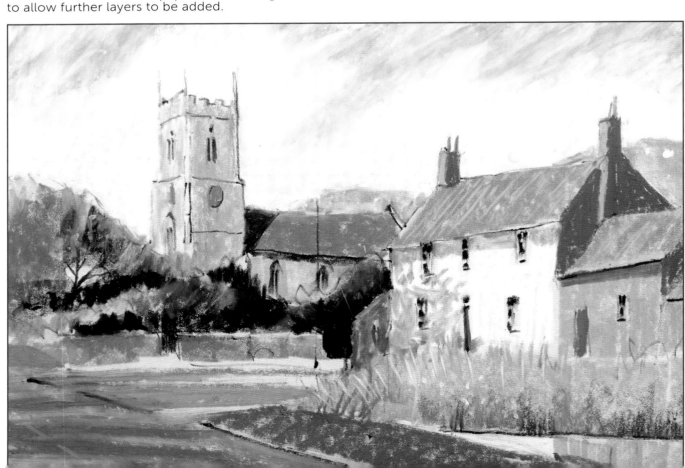

USING THE ENCAUSTIC METHOD WITH GLUE

Additional effects can be created as the painting progresses by attaching the oil pastels to the surface with hot glue, melting them with the heat from a hairdryer, and letting the pastels run – or by using sponging and spattering techniques (see page 27).

This technique works best with bright oil pastel colours such as light red or yellow.

(see page 27)

> **Tip**
> Keep your pastels at room temperature for this process as ice can make them brittle when cutting them to size.

1 Using a scalpel, cut off a piece of each pastel, about 8mm (¼in) long.

2 Use a hot-melt glue gun to stick your oil pastels to mount card.

The cut pastels, prior to gluing.

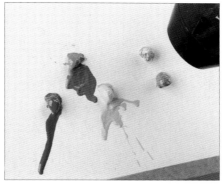

3 Blast the pastels with a hairdryer to melt them. This technique is ideal for use on abstract paintings, or in the depiction of poppies.

USING SOLVENTS TO PAINT A FURROWED FIELD

Interesting scenes can be created using solvents. I often start a painting this way and then apply dry oil pastel over to finish the work. Working oil pastel onto a surface first wetted with solvent produces some exciting and interesting marks. Brushes tend to get clogged and will require frequent cleaning in turpentine or thinners.

For this exercise, I have used alkyd-based flow aid for oil paints and distilled turpentine as the solvents, applied using an Isabay isocryl acrylic brush. The oil pastel is first worked onto a dry surface – here, a primed artists' canvas board.

1 Apply oil pastel to the dry surface – begin by scribbling in a star shape, using luminous yellow to represent a cloud. Surround the cloud area with pale blue, then soften the edge of the cloud with white pastel.

Tip

Solvents change the behaviour of the oil pastel: dip the oil pastel into solvent for a stronger mark as the pigment dissolves.

2 Paint the alkyd-based solvent into the sky areas with the acrylic brush.

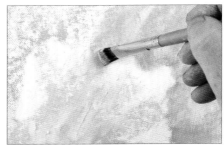

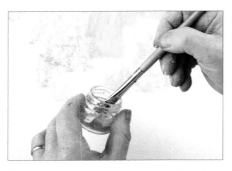

3 Use turpentine to wash your brush. Then go into the inner part of the cloud with the alkyd solvent.

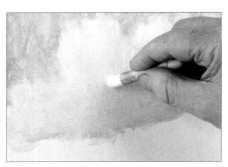

4 Work the white oil pastel into the wet surface.

5 Still working into the wet solvent surface, draw in the distant hill line using a brown-grey pastel (such as mummy).

6 Use olive green to scratch in a line of trees below the hill line. Dip the sap green oil pastel into solvent to create a darker mark below, for shadow.

7 Using the same brush, paint onto the surface below the hills and trees with distilled turpentine.

8 Wipe light English red in horizontal strokes into the wet surface over the turpentine.

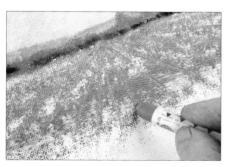

9 Create radiating lines from the distance to the foreground using yellow ochre – the yellow will push the brown of the fields out of the way.

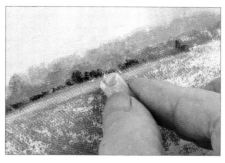

10 Run a highlight in cold grey into the distance in front of the tree line.

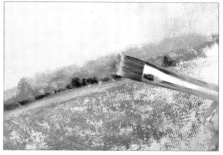

11 Scribble the lemon yellow and white oil pastels onto a palette, and mix in some more turpentine to give the pastel an oil-paint effect. Apply this vibrant yellow to the top edges of the trees.

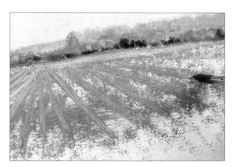

12 Finally, use a brush loaded with turpentine to refine the furrows in the field.

The finished exercise.

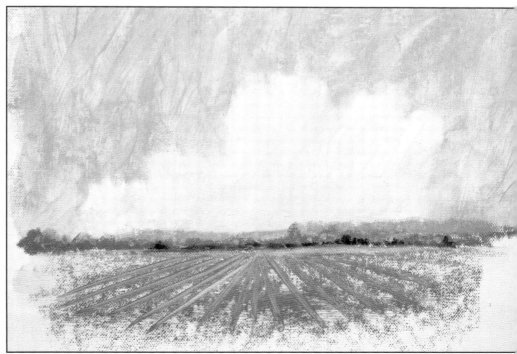

USING OIL PASTELS WITH OTHER MEDIA

I was inspired to read of Henry Moore (1898–1986) working on his paintings of crowds sheltering from bombing raids in the London Underground – a simple wash over a resist would magically make sleeping figures appear on the paper. Oil pastels can be used to achieve a similar result. Combined with the subtlety of watercolour, many interesting designs can be created. I particularly like painting flower blooms and then creating a background with colour washes.

USING OIL PASTEL WITH WATERCOLOUR

DAISIES

1 With the white pastel, scribble in some sky area at the top of the watercolour paper, then the beginnings of white petals further down. Use yellow deep for the flower centres towards the bottom of the paper.

2 Go back over the petals and the sky area with the white pastel. Apply it more thickly at the bottom of the paper and lighter at the top – the white at the top should appear almost scumbled (see page 25), so that the paper surface is still visible.

3 Fill in the shadow sides of the flower centres with yellow ochre.

4 Holding the flesh ochre oil pastel against the paper, put in some vertical stems using the flat edge of the pastel (see page 24).

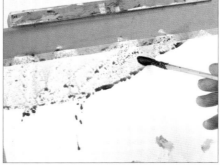

5 Using your squirrel-hair brush, paint French ultramarine blue watercolour over the top of the scene, beginning at the top of the paper and overlapping the scumbled white pastel.

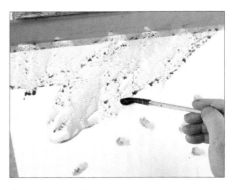

6 Take up quinacridone red watercolour and work further down the paper, over the flowerheads.

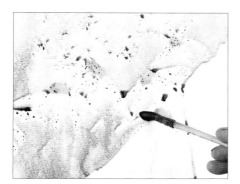

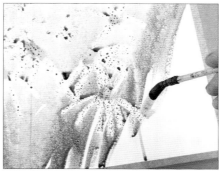

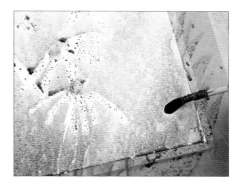

7 Return to the French ultramarine blue watercolour and blend the two colours – the blue and the red – further down over the flowers.

8 Mix up Sennelier yellow light and French ultramarine blue watercolours, and lay in some green grass towards the bottom-right corner of the painting.

9 Complete the watercolour wash with quinacridone red laid in in the very bottom-right corner.

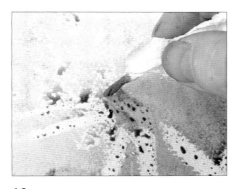

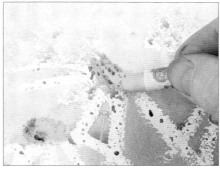

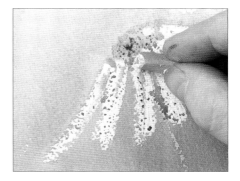

10 Roll up a scrap of kitchen paper and use this to remove any areas of watercolour that appear too dark. Allow the watercolour to dry. You can apply more oil pastel over the top of the paint when it has dried to develop the scene further.

11 Use the yellow deep oil pastel to go back over some of the flower centres; then go over the petals with the white oil pastel.

12 Finally, use the light grey pastel to put in areas of shadow on the petals.

Tip

Use a brush with natural-hair bristles rather than nylon so that the bristles won't pick up the oil pastel as you paint with the watercolour.

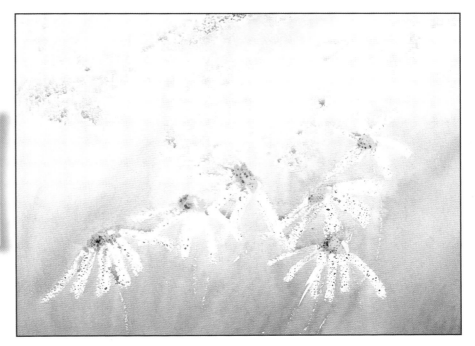

The finished painting.

USING OIL PASTEL WITH ACRYLIC INKS

I like working with acrylic inks, which maintain good colour intensity even when diluted with water. They also flow readily and mix easily with each other when applied over a watercolour surface.

I like to add oil pastel to subjects within the painting before adding the inks. They will then dry unevenly, creating interesting textures and effects. Sometimes when applying oil pastel over a pen drawing, lines can get lost but these can easily be recovered by scraping away the oil pastel with a scalpel to reveal the ink line.

COUNTRY HOUSE

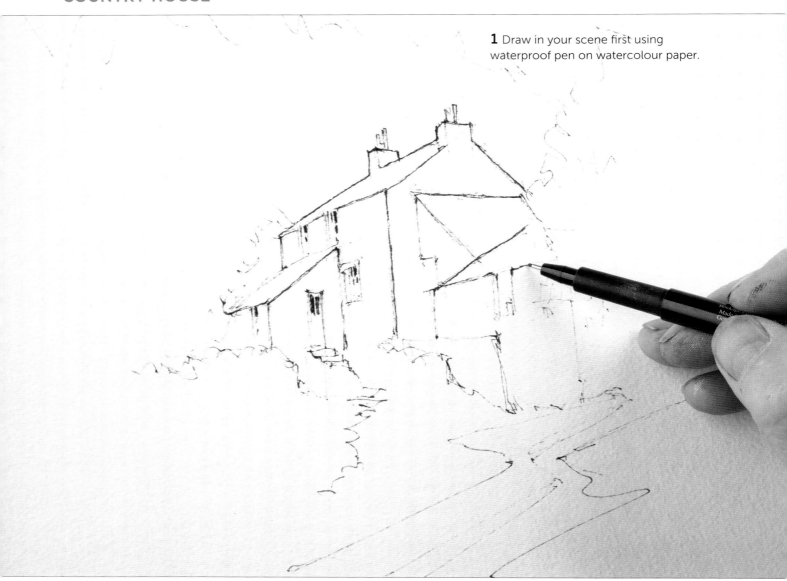

1 Draw in your scene first using waterproof pen on watercolour paper.

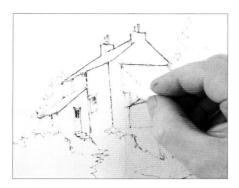

2 Imagining the light coming from the left of the scene, fill in the sunny, left-hand side of the cottage in white pastel.

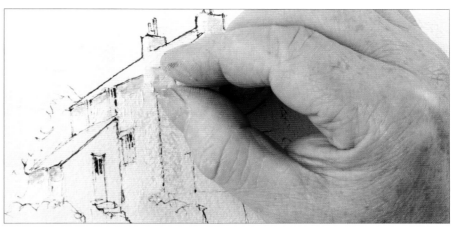

3 Use a cold grey pastel to fill in the sides of the building cast in shadow, and the shadows beneath the eaves.

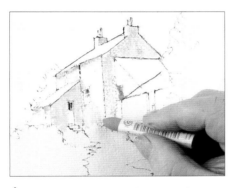

4 Increase the depth of the shadows with violet grey.

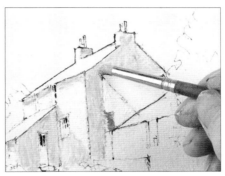

5 Use a size 2 colour shaper to soften the grey and violet areas, and erase any inadvertent bobbling.

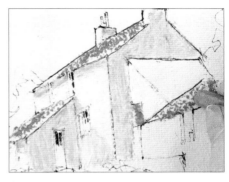

6 Fill in the main roofs of the cottage using a reddish brown grey pastel – leave the roof of the extension white until step 7.

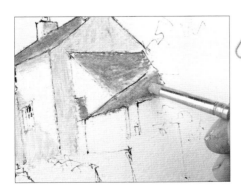

7 Fill in the extension roof using a light grey pastel, then soften this roof and the cottage roofs with the colour shaper.

Tip

Blending the pastels helps to prevent the acrylic inks being absorbed into the paper – the blended oil pastels form a barrier.

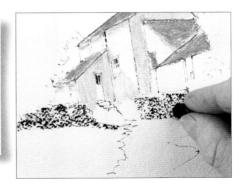

8 Working in downward motions, fill in a stone wall in front of the cottage using a Payne's grey oil pastel.

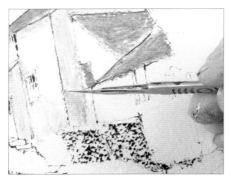

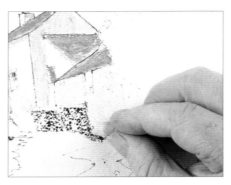

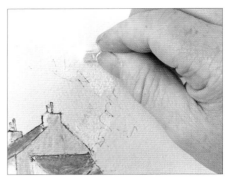

9 Use a scalpel to scrape back any areas of oil pastel that have overlapped, and recover the original pen lines – use the scalpel to reveal the ink line that runs down the edge of the building, and the lines inside each of the windows.

10 Fill in the nearmost front wall of the cottage with the flesh ochre pastel, working again in downward strokes.

11 Put some white pastel into the sky area, but leave some areas clear. Put the white into the path and foreground areas for texture.

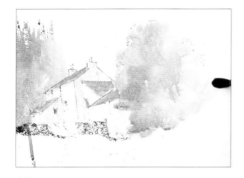

12 Mix a green with yellow ochre and indigo (blue) acrylic inks. Using a squirrel-hair brush, brush the green in over the foliage areas in the background and foreground. Don't worry if the colour runs – you can cover it over with oil pastel later.

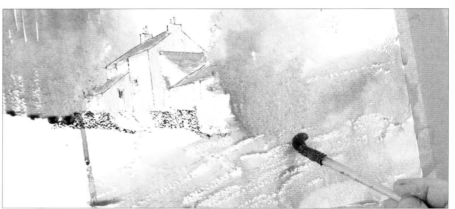

13 Add more yellow ochre to the green mix and brush in the foreground grasses.

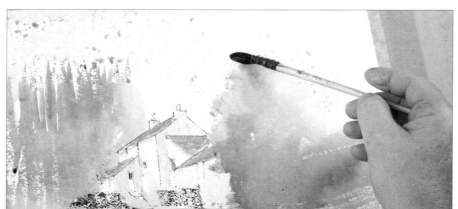

14 Put some indigo blue into the sky over the areas of white pastel. Then fill in the hill in the background in a dilute mix of crimson and indigo, with a dilute indigo to fill in the sky itself. Fill in any empty areas with a mix of yellow ochre and indigo. Drag the diluted wash of the hill straight over the shadowy side of the cottage. Allow to dry.

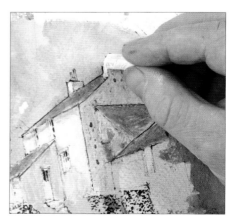

15 Use the white pastel to recover any areas that have been dulled by the wash.

16 Scribble some sap green into the background foliage to suggest conifers. Include some branch detail as well.

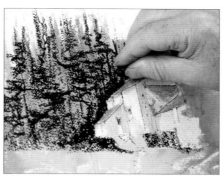

17 Switch to Payne's grey to push shadows into the trees and around the left edge of the cottage.

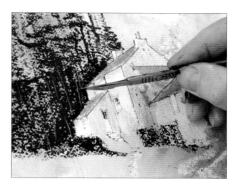

18 Use the scalpel again to recover the outer lines of the cottage, to neaten the roof lines, and reveal the washes of ink underneath the oil pastel among the foliage on the left of the cottage. Scrape out the chimney pots as well as the tree trunks.

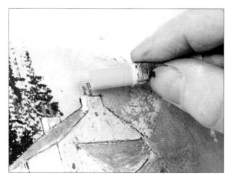

19 Where you have scraped out the chimney pots, fill them back in with the very edge of a stick of yellow lake.

20 Go over the distant hills on the right and in the centre of the scene with violet grey.

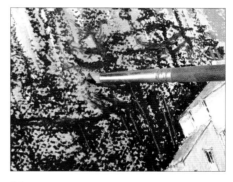

21 Using the colour shaper, mash in the greenery on the left of the cottage.

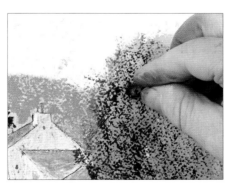

22 On the right-hand tree, use sap green to bring out the texture of the paper. Stroke the pastel from the bottom of the foliage upwards.

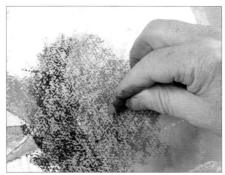

23 Use olive green to fill in the right-hand edge of the same tree.

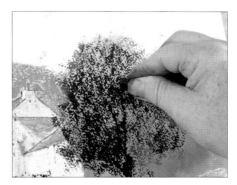

24 Darken the left-hand edge of the tree with sap green and use this darker pastel to add more depth to the foliage.

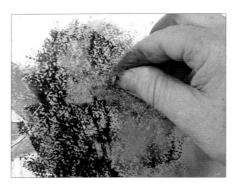

25 Scribble moss green pastel over the very top of the tree.

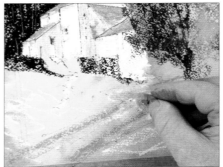

26 Follow the curves of the track in the foreground using the yellow ochre pastel, tracing around the edges of the path, then push yellow ochre into the grassy banks on the left of the track. Use the same pastel to put in some fields on the right of the cottage.

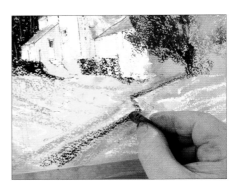

27 Use sap green to reinforce the track along the centre of the ridge.

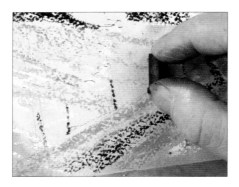

28 Holding the Payne's grey pastel vertically against the surface, draw in some fenceposts along the left-hand edge of the track.

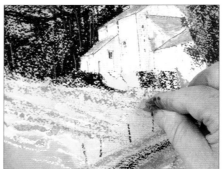

29 Bring a shadow in from the left-hand side of the scene, from an unseen tree, using the violet grey pastel.

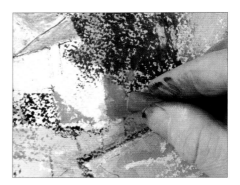

30 Block in the end wall of the cottage with the yellow ochre pastel, then go back over the yellow ochre with luminous yellow to break up the colour.

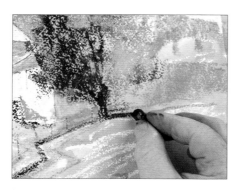

31 Lay in a shadow at the base of the right-hand tree using violet grey, then lay in a slightly darker cast shadow in Payne's grey.

32 Using a black coloured pencil, fill in the right-hand tree trunk, then darken the doorways and window frames, working over the top of the areas of white pastel.

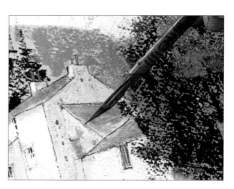

33 Scrape away more of the extension roof with the scalpel to recover the black pen line underneath.

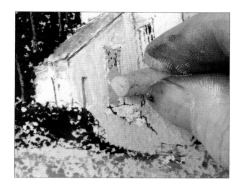 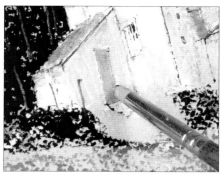 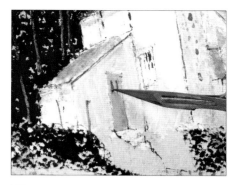

34 Use an English grey oil pastel to fill in the front door of the cottage, on the left-hand extension.

35 Blend the colour using the size 2 colour shaper.

36 Finally, use the very point of the scalpel to scrape away – and reveal – the windows in the front door, to complete the painting.

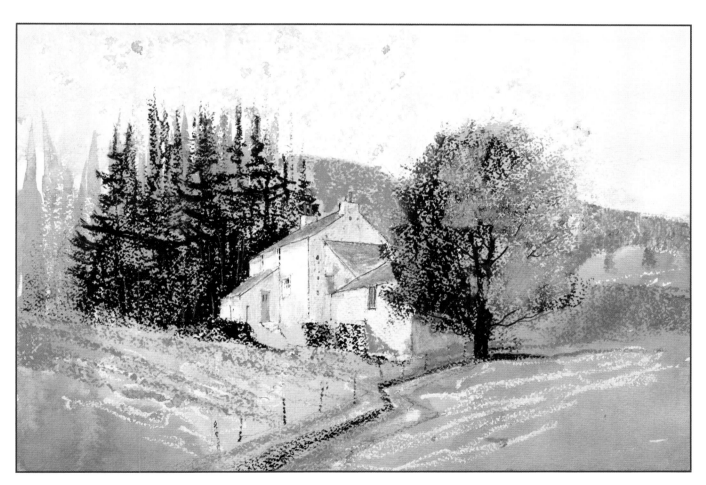

The finished painting.

PROJECTS

FLOWERS: POPPY FIELD

Flowers make great subjects for oil pastel paintings. The rich, opaque oil pastel colours slide easily over one another, helping to create a sense of vibrancy and movement. Most types of flowers lend themselves well to being represented in this medium, though I particularly like painting poppies as they present the perfect opportunity to exploit the rich selection of red and orange colours available.

The finished painting.

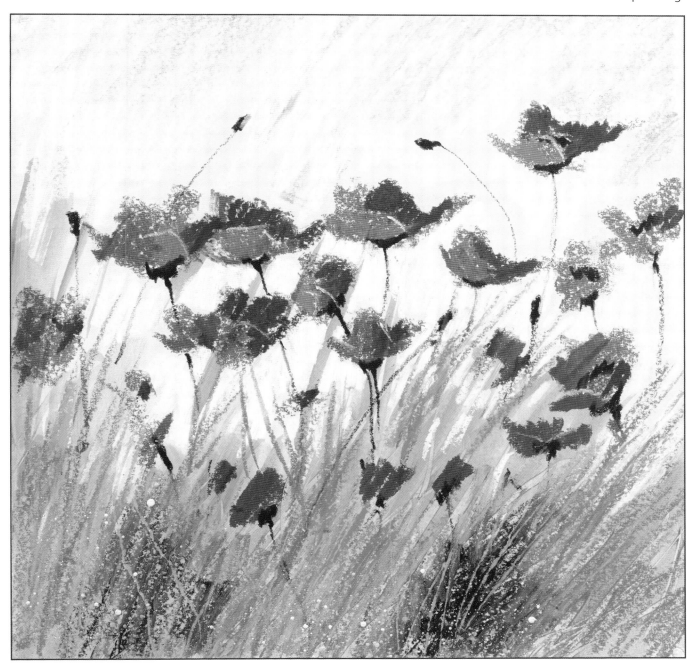

I like to develop the texture of the background grasses using acrylic paints and grooved mark-making tools. This technique is also useful when creating other subjects that have an abundance of textures like wild flowers, stalks, twigs and grasses. When working this way, it's possible to draw directly onto the textured background with oil pastel. The hit-and-miss method of its creation helps to produce accidental marks that contribute to the production of bright, colourful and expressive paintings.

YOU WILL NEED:

Surface: framer's mount card, 30 x 30cm (11¾ x 11¾in)

Tools: palette for acrylics; water; 2cm (¾in) flat nylon brush; two silicone catalyst contour blades; penknife (or other sharp knife); encaustic iron; Harris 5cm (2in) bristle brush

Pastel colours: red light; vermilion; ruby red; burnt umber; olive green; permanent green light; cinnabar green yellow; barite green; royal blue; white; pale blue; violet alizarin lake; yellow deep

Acrylic paint colours: cadmium yellow lemon hue; azure blue; cadmium red light hue

1 Begin with a short piece of a red light oil pastel to work in the initial shapes of the poppies. Scribble in roughly half a dozen poppy heads towards the top of the mount card. Work quickly to ensure that your flowerheads are not too regular or consistent in size.

2 Decant your acrylic paint colours into separate wells of a palette. Dilute the blue, then begin to grade the colours across the palette to mix a greeny-yellow, then darken this greeny-yellow with a hint of red. Make up enough dilute blue to cover your whole painting surface.

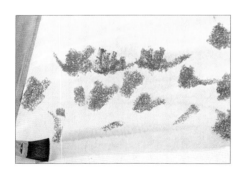

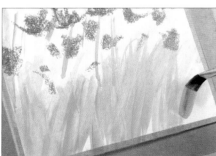

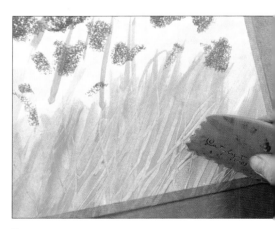

3 Using a 2cm (¾in) flat nylon brush, lay the dilute blue wash over the whole mount card, over the tops of the poppy heads.

4 Working upwards from the bottom of your painting area, apply thick, mixed-green acrylic paint in strokes, to lay in the foreground grasses.

5 Use one of the catalyst shapers to scrape up into the paint to create ridges, and suggest grasses. Use the edge of the blade for this process.

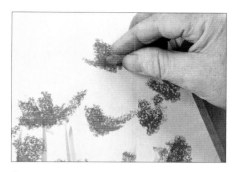

6 Push some vermilion oil pastel into some of the flowerheads.

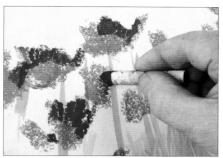

7 Then use ruby red to indicate a small amount of shadow on the insides – or right-hand sides – of each of the flowerheads.

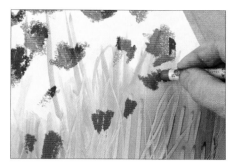

8 Switch to the red light pastel, and work around the flowerheads to define their shapes a little further. Then scribble some more reds in among the grasses.

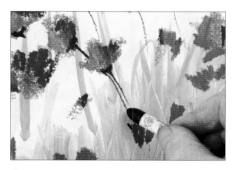

9 Introduce burnt umber to represent the seed heads inside and on the underside of the poppies. Pull the colour down quickly to create fine lines for stalks. Put in some individual seed heads as well.

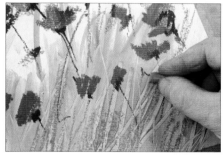

10 Go back in over the grasses with olive green.

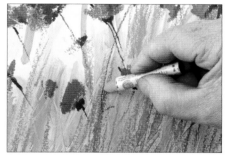

11 Strengthen and give dimension to the grasses, first using permanent green light, then cinnabar green yellow, then finally draw in some further grasses in barite green.

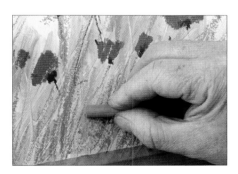

12 Push a little royal blue in among the grasses as well.

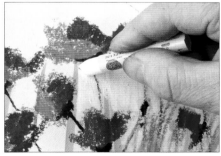

13 Come back in from the top with the white pastel. Using the tip, and taking care to avoid picking up any red, create little highlights through the grasses. This white will help the poppies stand out more. At this stage you can also use the white to modify some of the strokes you have made with the acrylic.

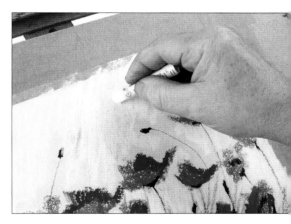

14 Take the white all the way up into the sky area.

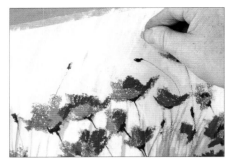

15 Break off a short piece of pale blue pastel and pull in the colour diagonally from the top-right corner. Leave as much – or as little – of the acrylic paint visible as you like.

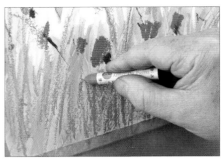

16 Move back into the foreground and use olive green to block in some more grass.

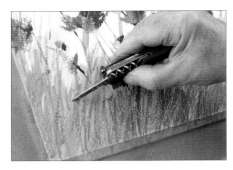

17 Use a sharp knife – such as a penknife – to scrape out some areas among the grasses, working down to the bottom of your painting.

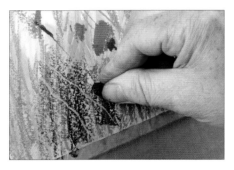

18 With violet alizarin lake, go over where you have scratched out with the knife. The grooves that you have made will now show through.

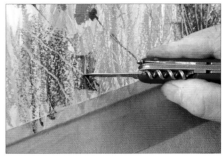

19 Reshape some of the grasses with the knife, then go back over the grasses with barite green.

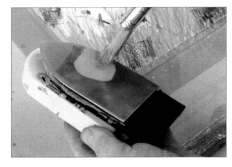

20 Melt a yellow deep oil pastel onto the plate of an encaustic iron. Using a 5cm (2in) bristle brush with half of its bristles cut out, flick the colour over the painting (see page 27). It is best to lay your board flat for this technique.

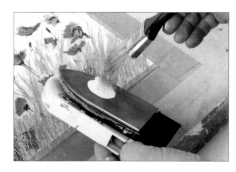

21 Repeat the encaustic spattering in step 20, using a melted white pastel dissolved with solvent.

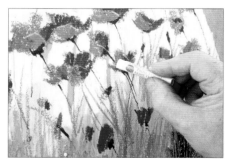

22 Use a solid stick of white pastel to put in some highlights on a few of the petals, to finish your painting.

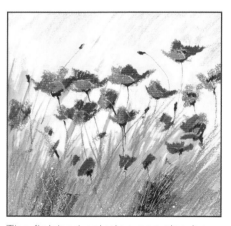

The finished painting can also be seen on page 45.

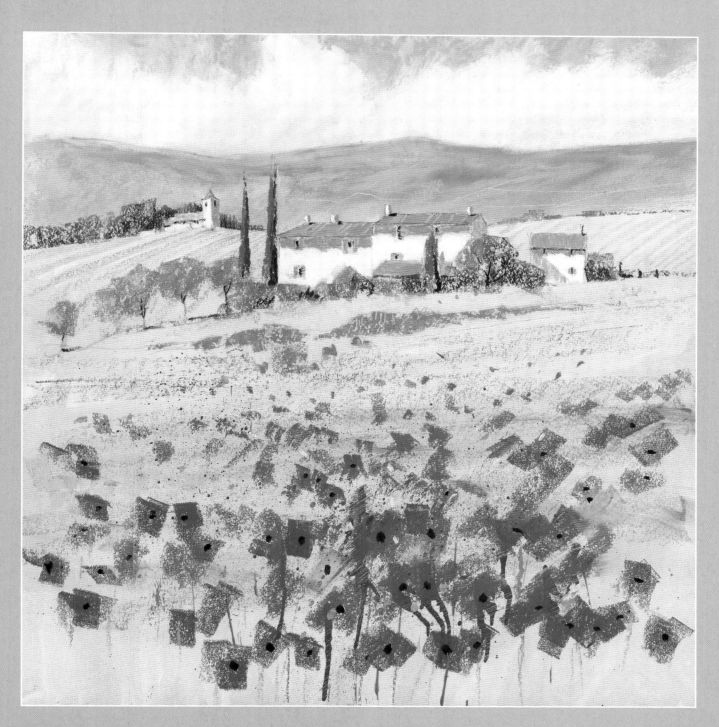

Provençale Farmhouses
45.75 x 45.75cm (18 x 18in)
Painted on framer's mount card.

The poppies in the foreground were created by gluing red oil pastel to the card and melting them with a hairdryer. A stronger red was then applied to bring out the poppy shapes, before flicking royal blue from an encaustic iron for the cornflowers.

TREES AND FOLIAGE: NORFOLK LANE

This project demonstrates further the versatility of the oil pastel medium. Picasso was particularly keen to exploit one of the primary benefits of oil pastels which was that they would work well on almost any surface.

For this subject – trees and foliage – I have chosen to paint this scene on plywood board. I love the way that the texture of plywood reacts with oil pastel, making the creation of texture and pattern within trees and grasses almost effortless. The underlying texture of the wood also tends to show through on finished paintings which adds to the end effect.

The finished painting.

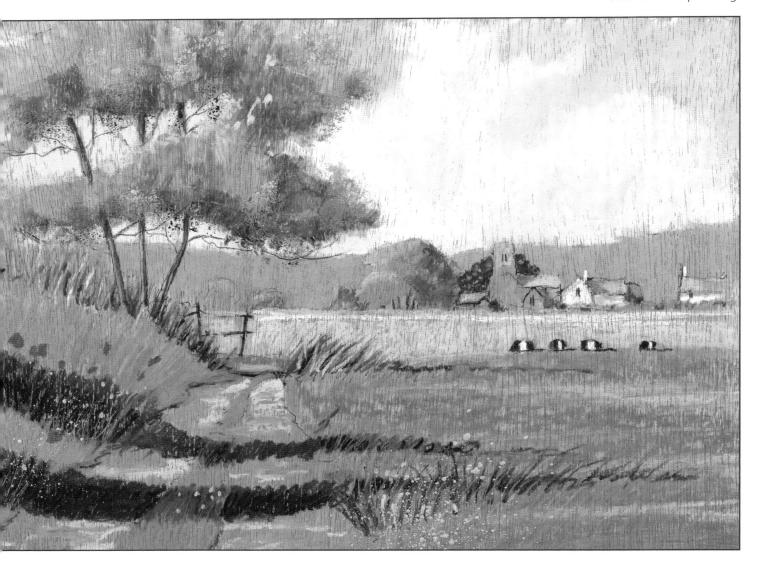

YOU WILL NEED:

Surface: hardwood plywood panel, 38 x 28.5cm (15 x 11¼in)

Tools: dip pen with steel nib; colour shaper (size 6); coloured pencil (black); encaustic iron; mahlstick; penknife

Pastel colours: olive green; white; luminous yellow; bright yellow; pale blue; light grey; violet grey; yellow deep; vermilion; yellow ochre; royal blue; burnt sienna; sap green; burnt umber; green yellow light; Payne's grey; barite green; pine green; English grey; red light; lemon yellow

Other: acrylic ink (black); car-washing sponge

This subject involves a little preliminary drawing to lay out an imaginary scene of a typical village at the end of a curving lane, in Norfolk, UK. The subject is dominated by a tree in full foliage to the left of the scene.

I enjoy creating outlines in ink and for this subject I chose to work with a steel nib dip pen and black acrylic ink, both of which work well on a plywood surface. People often worry about making mistakes when drawing directly onto a surface with ink, but these can be gently sanded away when it is dry or advantage can be taken of the opaque properties of oil pastel to cover over any errors.

Tips

I've painted this scene on a hardwood plywood panel, but any hardwood would do: the thinner the better. Tape the plywood down to your board to avoid distortion.

You would usually prime plywood but when working with oil pastels you don't need to.

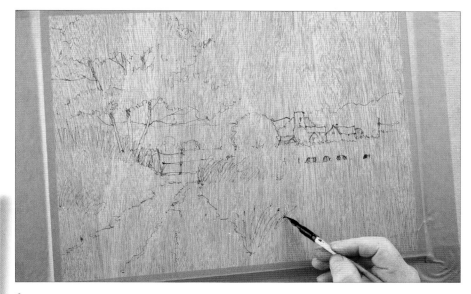

1 First, paint your scene onto the plywood with the dip pen using black acrylic ink.

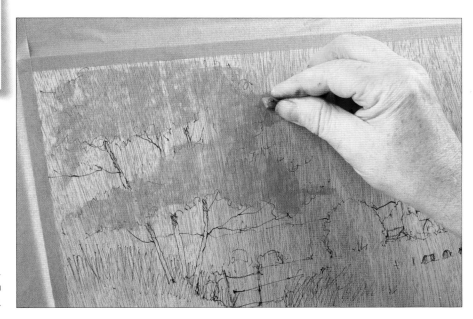

2 Starting with an olive green oil pastel, block in the main shapes of the tree on the left of the scene.

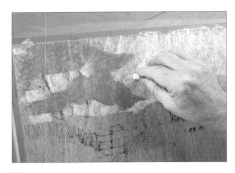

3 Create an underpainting with the white pastel. This provides a good grounding onto which you can add colour, as colour added directly onto the plywood can be too intense. Be careful that you don't pick up any green from the tree as you work with the white pastel. Pull the white strokes into the tree, and wipe off the tip of the pastel after every stroke.

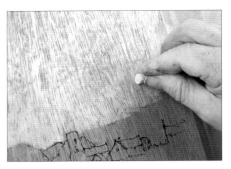

4 Apply luminous yellow into the lower part of the horizon in downward strokes, keeping the colour subtle. The texture of the wood will show through the wood nicely here.

5 With a pale blue pastel, use negative shading around the white sky area to create some cloud shapes.

6 Once you have defined your cloud edges, add a little more white into the cloud areas to strengthen them. Press the oil pastel quite solidly into the board to push the colour in.

7 Introduce some light grey to create cloud shadows.

8 Go over the grey shadows with more luminous yellow, again pressing the oil pastel quite hard into the plywood surface in order to blend the grey into the white of the clouds.

9 With your finger, blend the pale blue down into the cloud shapes. Add more white into the sky if you feel it is necessary.

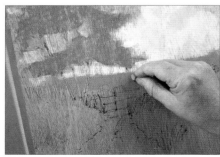

10 Scribble a line of distant trees into the horizon line using violet grey.

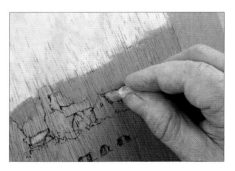

11 Use a yellow deep oil pastel to fill in some of the roofs of the buildings and scrape over them with a deeper orange – such as vermilion. Use white pastel to fill in some of the lower buildings themselves.

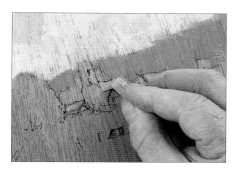

12 Apply light grey to the roof of the church.

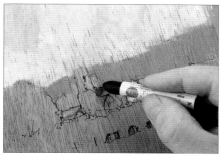

13 Use Payne's grey to suggest the shadow cast from the church tower onto the church roof.

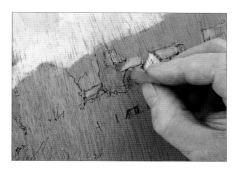

14 Block in the church tower itself using yellow ochre.

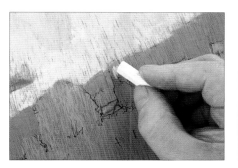

15 Mix in a little white pastel near the top of the tower as a highlight.

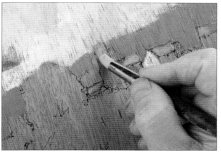

16 Use a colour shaper to push the white into the yellow ochre of the tower.

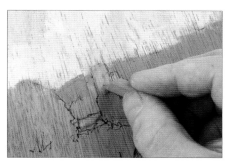

17 Use a dash of royal blue to represent the clock on the face of the tower.

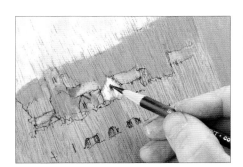

18 Use a black coloured pencil to draw in the details of the belfry, and to fill in the finer details on the fronts of each of the distant buildings.

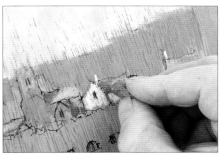

19 Create shadows on each of the roofs in burnt sienna – make sure these correspond with the direction of the shadow on the church roof.

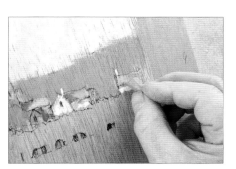

20 Take up the violet grey pastel again, and create delicate shadows under the eaves of any of the buildings you have filled in with the white pastel.

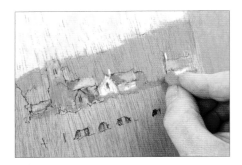

21 Run a line of foliage in olive green along the bottom edges of the buildings, and block in the bush on the left of the church.

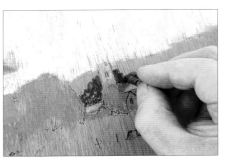

22 Using sap green, bring forward the church tower by scribbling in the tree that stands directly behind the church (see page 24).

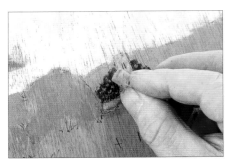

23 Stab or dash a couple of sky holes into the tree using the violet grey pastel (see page 25).

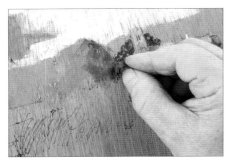

24 Put in a few more dark areas along the foliage line in the sap green.

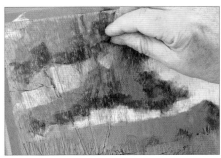

25 Sweep the sap green up into the large tree on the left of the scene.

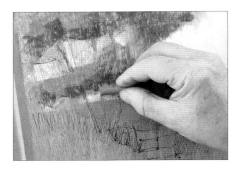

26 Lay in the trunks using yellow ochre.

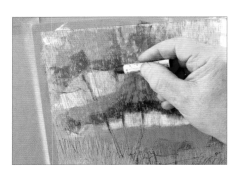

27 Use burnt umber to represent the cast shadows on the thicker parts of the tree trunks.

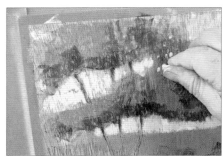

28 With the luminous yellow, stab in some sky holes within the foliage of the large tree.

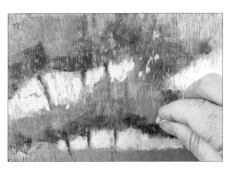

29 Use the green yellow light pastel to reintroduce highlights to some of the areas of foliage.

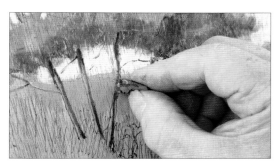

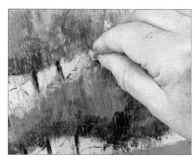

30 Put in some of the more shadowy sides of the trees with Payne's grey. To lay in the fine branches, roll and rotate the pastel between your fingers, and create a broken line. Stab or dash the pastel onto the board to ground the underlying white and yellow pastel into the plywood surface. Fill in more Payne's grey where the trunk emerges from the foliage, and run the dark colour down the right-hand side of the trunk.

31 Pick up the green yellow light again and stab or dash more colour into the surface over the foliage.

32 Melt part of a green yellow light pastel and an olive green pastel, with a hint of Payne's grey on the plate of an encaustic iron.

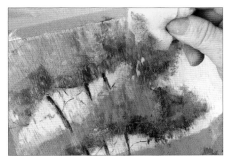

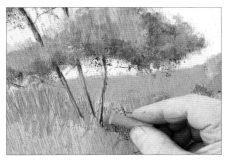

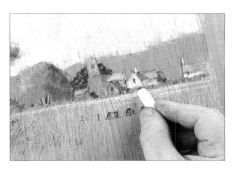

33 Tear a sponge in half and turn it inside out. Dab the colours that you have melted onto the iron at step 32 into the foliage.

34 Scribble yellow ochre into the foliage on the left of the scene.

35 Run yellow deep along the front of the buildings, then follow up with a little white pastel to enhance the highlights.

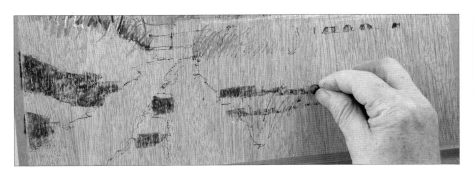

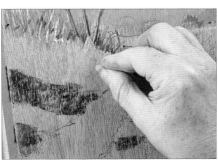

36 Move into the foreground. Use sap green to lay in the shadows of unseen trees coming in from the left. Be careful to avoid the track as you draw in the shadows.

37 Fill in the grassy bank with bright yellow.

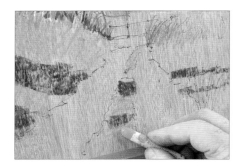

38 Fill in the dips in the centre of the track with barite green.

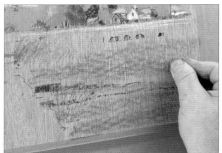

39 Sweep the olive green pastel horizontally over the foreground on the right of the painting, then scribble in grasses along the bank on the left.

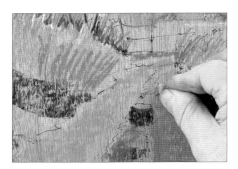

40 Fill in the track itself using yellow ochre.

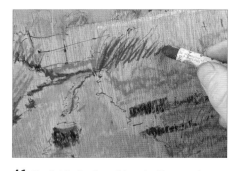

41 Scribble in the ridge in the centre of the track using a pine green pastel. Run the same green along the left edge of the track, then draw in some loose grasses at the end of the track, to the right, alongside the wire fence.

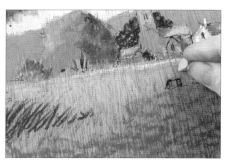

42 Fill in the middle ground using the green yellow light pastel.

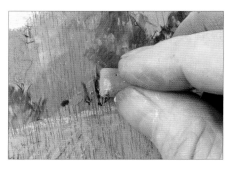

43 Fill in the gaps at the base of the smaller trees (next to the church) using violet grey between the trunks.

44 Move back into the foreground. Run yellow ochre into the foreground, back along the track then into the grasses on the left of the bank.

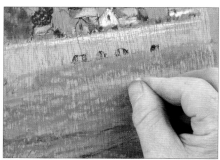

45 Go back over the field area with the green yellow light.

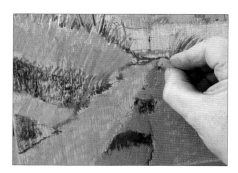

46 Run olive green up along the ridge in the centre of the track.

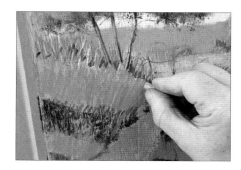

47 Use the yellow deep to scribble in more grasses on both sides of the track and along the midground in front of the cows.

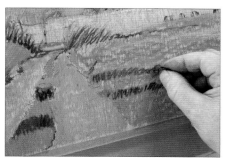

48 Go back over the shadows in the foreground field and across the central ridge of the track with sap green.

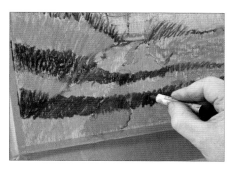

49 Fill in the shadows at the base of the bank, in the recessed parts of the track, with burnt umber.

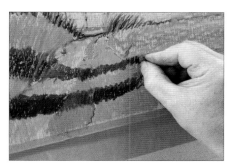

50 Strengthen the burnt umber shadows with Payne's grey.

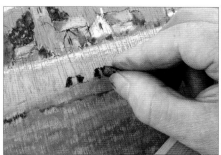

51 Using a mahlstick to avoid smudging your work, paint in the darker parts of the cows in the midground in Payne's grey. Fill in the cows' white bands in the white pastel, then draw in their shadows in Payne's grey again.

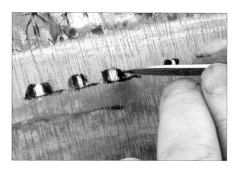

52 Use the tip of a knife – such as a penknife – to correct and refine the shapes of the cows.

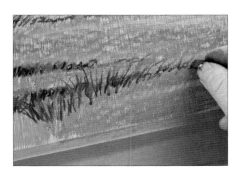

53 Draw in some more foreground grasses using sap green.

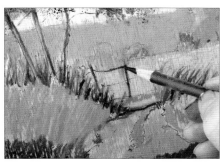

54 Fill in the fence with the black coloured pencil.

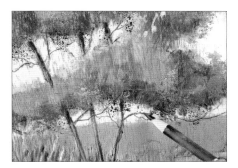

55 Use the black pencil to add a few more branches to the trees, and sharpen up the edges of the trunks. Fill in some more background detail – on the buildings – with the pencil at this stage as well.

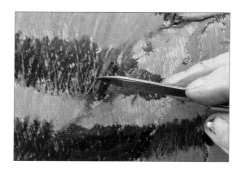

56 Use the penknife to scrape out some finer grasses along the bank and the track.

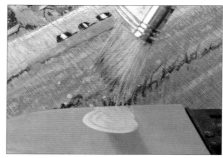

57 Repeat the encaustic spattering technique (see page 27) with English grey pastel melted onto the plate of an encaustic iron. Lay your board flat and flick the melted oil pastel over the painting with the cut-down bristle brush.

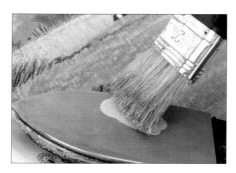

58 Melt down a small amount of lemon yellow pastel, and flick this into the field area as well.

59 Stand your board back upright. Using red light, dot some poppies into the bank.

60 Dot some additional colour – blue – into the bank and the central grassy ridge using the English grey pastel.

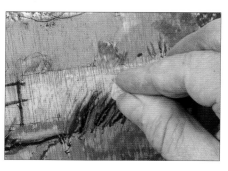

61 Tidy up the edges of the field and the distant grasses using green yellow light.

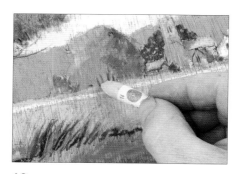

62 Using the light grey pastel, fill in the gap in the distance at the top of the field.

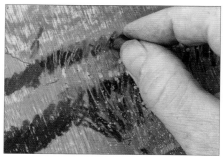

63 Use olive green to tidy up the grasses along the track, then go back over the grasses here with Payne's grey.

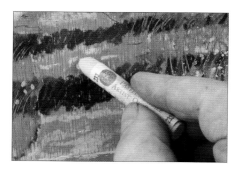

64 Scribble luminous yellow in patches along the track for puddle reflections, and go back over with yellow ochre to darken. Finally, add some highlights to the distant tree using green yellow light.

The finished painting can be seen on page 50.

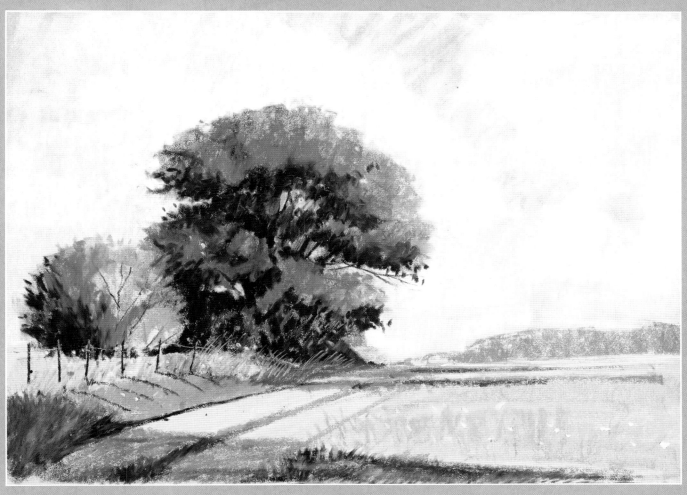

Greetham Lane, Rutland, UK
33 x 22.75cm (13 x 9in)
Painted on Clairefontaine maize pastelmat paper.

The foliage shapes were created by blending the greens with a colour shaper, after which sky holes were stabbed in and branch detail added with a black coloured pencil.

STREET SCENES: VENICE

People are often reluctant to include figures in a painting as they can seem out of place or artificially rendered, but who can resist the crowds that regularly throng the streets of Venice?

Where there are crowds, there is often architecture present, which means some care must be taken to observe perspective within the scene. From a standing viewpoint, extending a horizontal line through the heads of the crowds will create an eye line – this is the point where the vanishing points of the buildings will usually converge. Pay attention to the angles of the rooftops and lose the pavements amongst the legs of the crowds and the perspective will usually look after itself.

The finished painting.

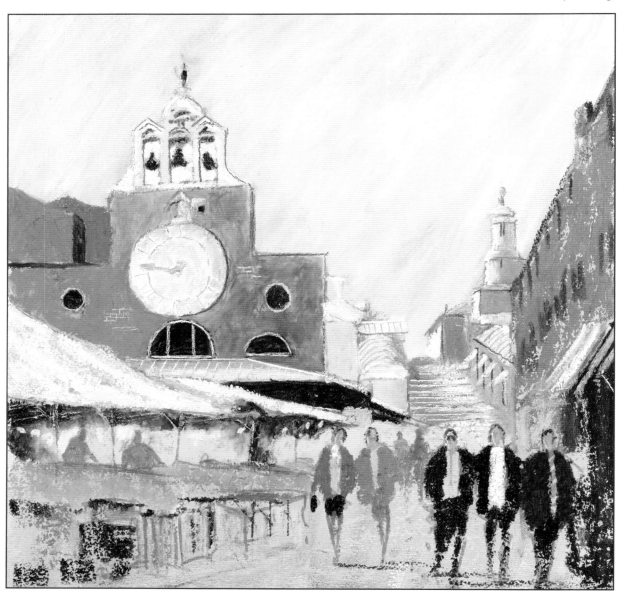

PAINTING PEOPLE IN OIL PASTEL

People standing on a flat surface are easier to paint from a standing viewpoint. Looking into the distance, all the heads of adults appear to be the same level.

Generally for figures, if they're standing on a flat surface and I am standing, all the heads should be at the same level, including mine.

1 Draw a straight line at the top of the scene. Think of it as a clothes line.

2 Use a flesh ochre oil pastel to dot in a line of heads. Don't create circular heads – make these oval.

3 Put in the body, in proportion to the head. If the body is facing you, define it with some oversized lapels – these can be angled to suggest the angle of the body.

4 Next, put in your people's legs in trousers, or skirts and tights. Taper their legs, and don't draw in their feet.

5 Finally, put in some shadows in small, horizontal marks in violet grey at the bases of the legs.

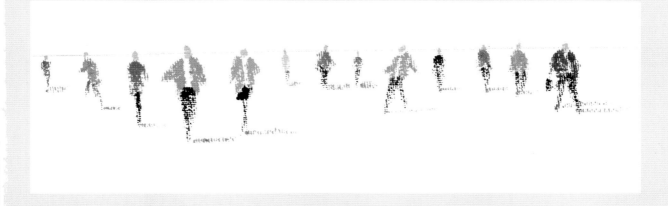

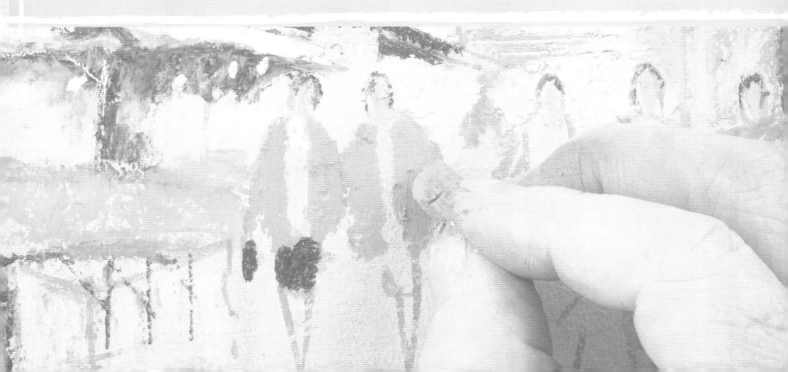

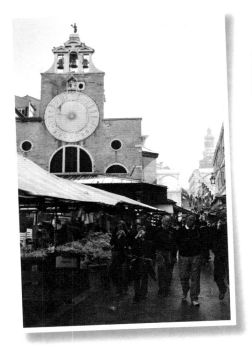

Above: the reference photograph that inspired this scene.

YOU WILL NEED:

Surface: primed hardboard surface, 30.5 x 30.5cm (12 x 12in)

Tools: 2cm (¾in) flat brush; Tombow pen (grey); colour shapers (sizes 6 and 2); scalpel; mahlstick; coloured pencils (steel grey; white; black; blue)

Pastel colours: violet grey; white; luminous yellow; pale blue; terra cotta; cold grey; red brown; burnt umber; Payne's grey; yellow deep; pale grey; mummy; light grey; burnt sienna; pine green; reddish brown grey; vermilion; flesh ochre; royal blue; pink; light English red; grey-green; violet alizarin lake

Acrylic colours: lemon yellow; cadmium red hue

Note

I like to use a Tombow pen when working on gessoed board – some of the softer grey pens are great for suggesting the lines and edges without things becoming too detailed. You can also see your original pen lines through your oil pastels.

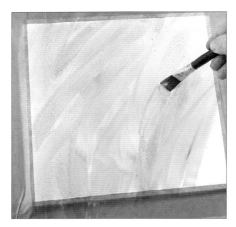

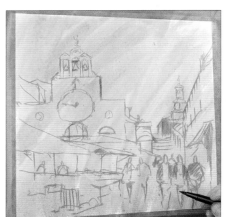

1 Prepare your hardboard surface with lemon yellow and cadmium red hue acrylic paint. Start in the middle of your board and cover the whole surface with a combination of the two colours using a 2cm (¾in) flat brush. Allow to dry.

2 Draw into the dry wash with a grey Tombow pen. Use the pen to outline the church and the market stalls.

Tip

If you are right-handed, work from top to bottom, left to right, when applying oil pastel so you always leave yourself space to rest your hand without smudging your painting.

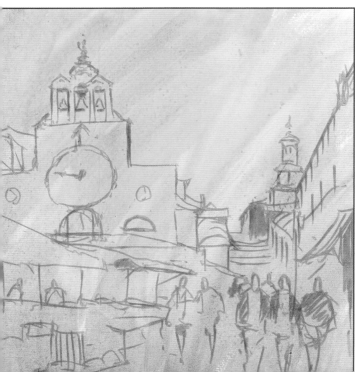

The wash and preliminary outline sketch.

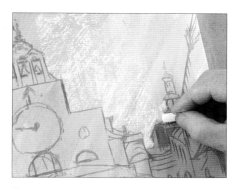

3 Begin with the white pastel to fill the whole sky area between the buildings on either side of the bridge. Fill in the gaps between the bells in the belfry.

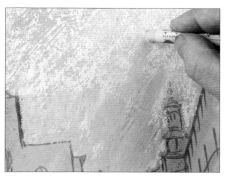

4 Run luminous yellow up into the sky in long, diagonal strokes.

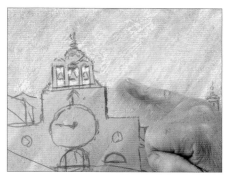

5 Go back over the sky with a pale blue pastel at the same angle, using looser strokes. Then use your finger to blend the colour down. Go back over the sky area with white if you have applied too much blue.

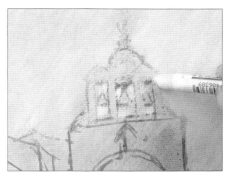

6 Fill in the top of the clock tower using light grey.

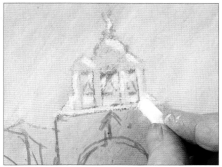

7 Work some white over the light grey to give the tower greater contrast against the sky.

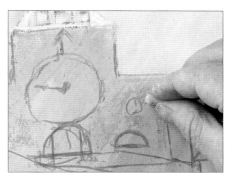

8 Add terra cotta to the brickwork of the clock tower.

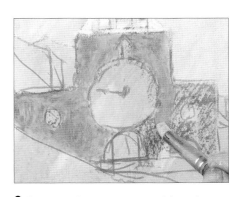

9 Go over the terra cotta with red brown, then blend the colour down using the colour shaper.

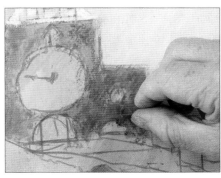

10 Scribble in some burnt umber for a hint of darker colour on the face of the tower, and use the colour shaper to blend down the colour again.

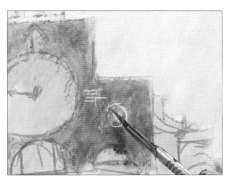

11 With the sharp tip of a scalpel, scrape out some of the pastel layer to suggest a small amount of brickwork in the fascia of the clock tower. Scrape out the edge of the circular window on the right.

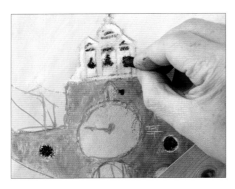

12 Fill in both circular windows with Payne's grey. Then, using a mahlstick to protect your work, fill in the bells and the upper details at the very top of the tower, still working with Payne's grey. Put in a spire, as well.

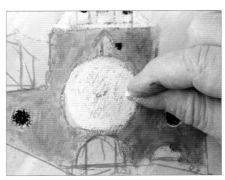

13 Push some white into the clockface.

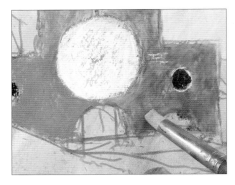

14 Go back over the front of the tower with terra cotta again, and blend the colour with the colour shaper.

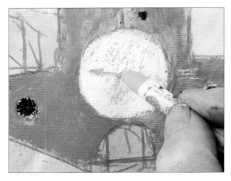

15 Draw in the clock hand with yellow deep.

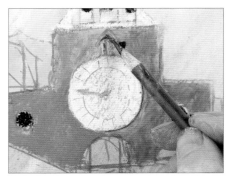

16 Use a steel grey coloured pencil to define the bevelled clockface and its sections. Then use the pencil to darken the clockface. Outline the small window directly above it in an arrow shape to suggest a recess.

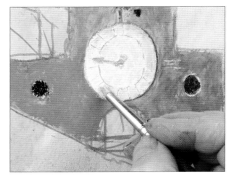

17 Drop down to a size 2 colour shaper to blend the colour inside the clockface and around its edges.

18 Use Payne's grey to define the two semi-circular windows beneath the clock. Block them in entirely in Payne's grey – you will scrape out the details of the larger window afterwards. Use the smaller colour shaper (size 2) to blend in the grey and refine the shape of the windows.

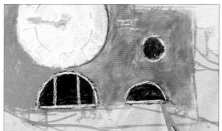

19 Use the scalpel to create panes in the larger window beneath the clockface. Scratch around the inside edges of the window, and scratch out a ledge.

Go around the inside edges of both circular windows, and the smaller semi-circular window in the same way. Scratch in a little more brickwork on the fascia.

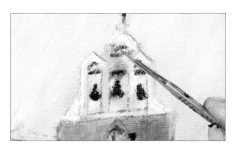

20 Rest on your mahlstick and scratch some of the design back in to the top of the tower, revealing the gesso primer under the layer of oil pastel.

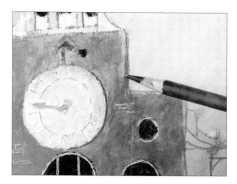

21 Use the steel grey pencil to fill in a little more shadow at the top of the tower.

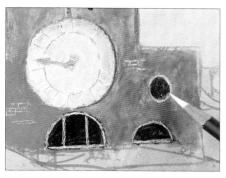

22 Go over the scratched-out areas around the insides of the circular windows with a white coloured pencil.

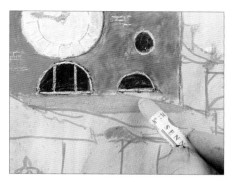

23 Use the pale grey pastel to fill in a little porch roof beneath the clock windows. With the terra cotta, go back over the top edge of the porch roof, then blend up with the smaller (size 2) colour shaper.

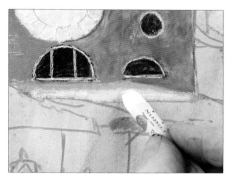

24 Put in some white over the pale grey in gentle, horizontal strokes.

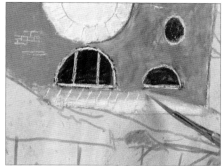

25 Scratch in some tile detail with the scalpel, following the shape of the roof. Scratch out the very top edge of the roof as well.

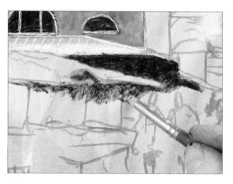

26 Fill in the shadow areas under the porch roof with Payne's grey. Blend or soften these with the small colour shaper, and spread the Payne's grey as far as it will go under the roofs of the market stalls.

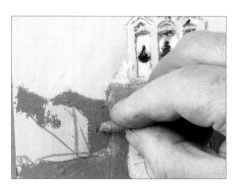

27 Use a mummy oil pastel to block in the side walls of the building on the left of the clock tower.

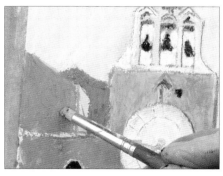

28 Use terra cotta to fill in the front-facing walls. Soften any lumps on the surface with a colour shaper.

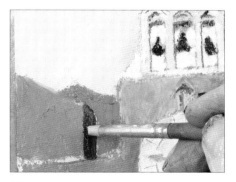

29 Use burnt umber to put in the shadow side of the building adjacent to the tower. Blend the colour with the colour shaper and take off some of the burnt umber at the same time. Use the blender like a paintbrush to fill in the bottom edge of the wall against the clock tower.

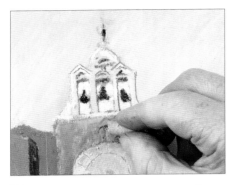

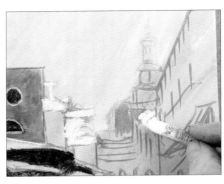

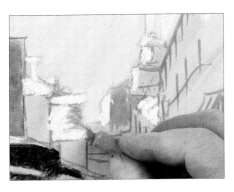

30 Use light grey to fill in the small arrow-shaped recess above the clock face. Add a dash of white pastel on top of the grey to further define the recess, then continue to use the white to block in the roofs of the buildings that are below...

31 ...and opposite, such as the side of the distant bridge.

32 With yellow deep, dot in some details of the roof tops on the right of the bridge, and yellow ochre on the canopies over the bridge itself. Block in the distant, front-facing wall on the right of the bridge in light grey and blend this colour down with the small colour shaper.

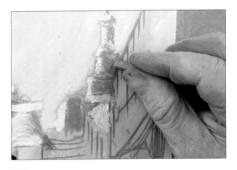

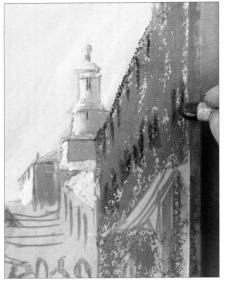

33 Fill in the shadowed side of the tower on the right of the bridge with violet grey, and again, blend with the colour shaper. Use a black coloured pencil to refine the edges of this tower. Then put in some details along the wall of the farmost building on the right, behind this tower.

34 Fill in the walls of the right-hand-side buildings with red brown – work over the red brown with a darker brown such as burnt umber or burnt sienna, then use Payne's grey to fill in the top roof line, and the windows. Use pine green to suggest the shutters of the windows.

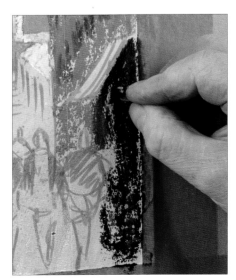

36 Draw in stripes of white and pale blue for a canopy over the shop window.

35 Put more Payne's grey into the shop window at the bottom-right of the scene.

37 Work with reddish brown grey to block in the set of shops that lead up the steps towards the bridge. Scrape out the doorways of these shops with the scalpel, and scrape out a bracket underneath the canopy over the foremost shop.

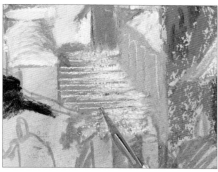

38 Use violet grey to block in the left edges of the steps – leave some areas of light between the steps themselves. Draw the white pastel in from the right-hand side of the steps, to meet the violet. Scratch out the tops of the steps with the scalpel.

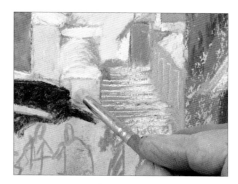

39 Fill in the face of the building on the left of the steps with pale grey, and blend the colour with a colour shaper so that part of the underpainting blends into the grey.

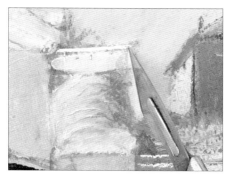

40 Define the top edge of the roof of the Rialto bridge (on the left of the steps) by scraping out with the tip of the scalpel. Then go in with the steel grey coloured pencil to mark in some roof detail.

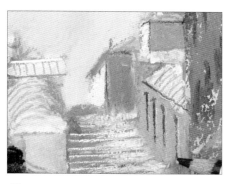

41 With the black coloured pencil, fill in the recesses of the windows leading up to the bridge, then draw in a little bit of white pastel on top of the canopies.

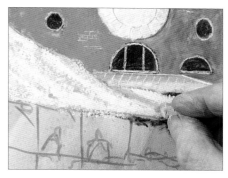

42 Use the white pastel to block in the tops of the market stall canopies. Go over the canopies with pale grey in diagonal strokes.

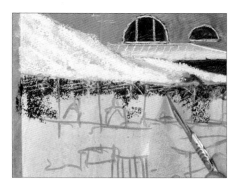

43 Add in more Payne's grey under the canopies of the market stalls, then use the tip of the scalpel to scrape out the rigging of the canopies.

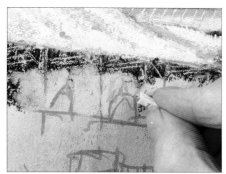

44 Separate the stalls beneath the canopies using luminous yellow, then bring this colour all the way across the bottom of the steps to the wall of the opposite building.

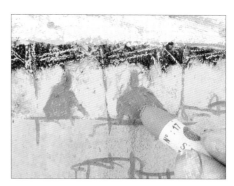

45 Put in some shadowy figures beneath the canopies using the awnings in reddish brown grey. Use violet grey to give the figures some shadows. Soften the background with the small colour shaper – soften the undersides of the canopies as well.

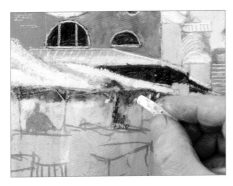

46 Put in some areas of white under the canopies to reintroduce light and depth.

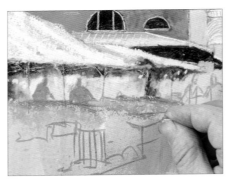

47 Dash in some fruit on the market stalls using vermilion. Dash in some yellow deep on top for variety.

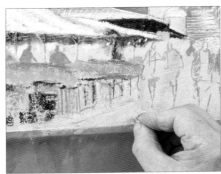

48 Fill in the fronts of the stalls in light grey then fill in the shadow sides of the stalls and crates using Payne's grey. Use the very corner of the pastel to define the edges of the crates, then go back to light grey to brush in some foreground. At this point, you can overlap the walking figures.

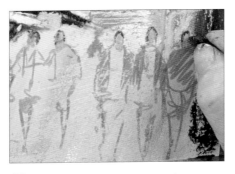

49 Use flesh ochre to create the shapes of the faces of the walking figures. Fill in their hair with Payne's grey, then, with a scalpel, scratch out a highlight on the side of each of their faces.

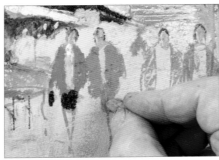

50 Draw in the jacket of the figure on the far left in royal blue, her shirt in pink – its collar in white – and her skirt and bag in Payne's grey. Colour the jacket of the woman on her right in light English red, with grey-green for her skirt.

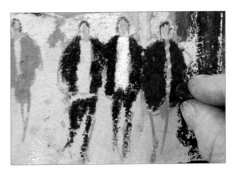

51 Use Payne's grey to fill in the jackets and trousers of the two central figures, with a white shirt for the figure on the centre-right. Give the figure on the far right a coat in violet alizarin lake; and give the far right-hand figures trouser in Payne's grey.

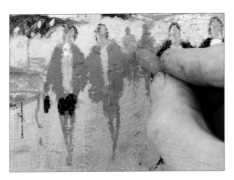

52 Return to the figures on the left, and give them both reddish brown grey tights. Use the same grey to fill in a few shadowy figures behind them. Draw in the figures' shadows in Payne's grey.

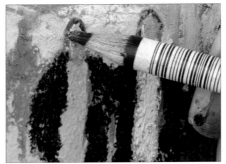

53 Give the central figure sunglasses, using the black coloured pencil.

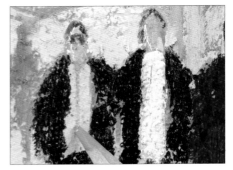

54 Finally, use a blue coloured pencil to draw in a thin tie on the central figure, to complete the scene.

The finished painting can be seen on page 60.

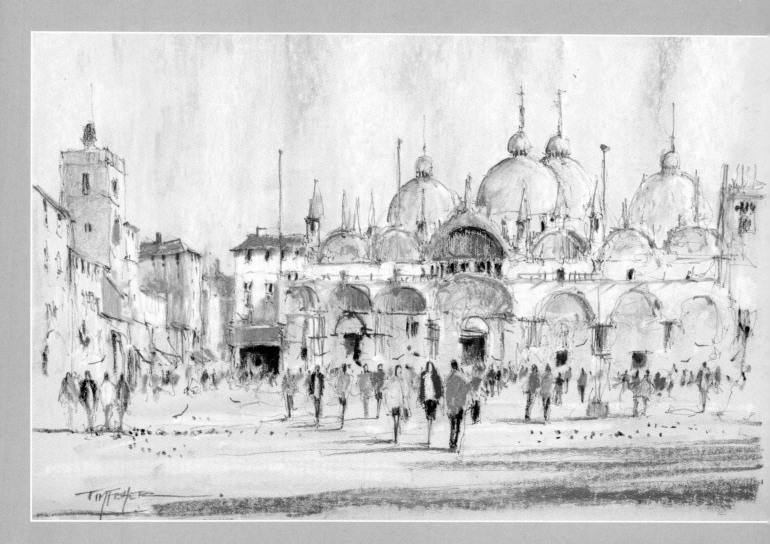

St Mark's Square, Venice
33 x 22.9cm (13 x 9in)
Painted on Clairefontaine maize pastelmat paper.
This surface responds in a similar way to
primed hardboard.

Adding the figures onto a flat surface,
I tried to keep all the heads at the same level. To get
a smooth transition of colour, the buildings were
blended using a colour shaper.

BUILDINGS: STAITHES COTTAGES

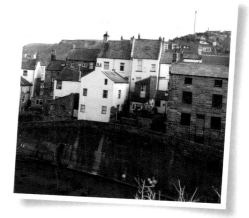

The reference photograph.

My particular interest in this subject was the depiction of the rows of fishermen's cottages facing outwards and set against a backdrop of blue-grey cliffs in this quaint coastal village in Yorkshire, UK. The bright orange rooftops – mixed with grey slate buildings – made this an attractive subject to produce in oil pastel.

The finished painting.

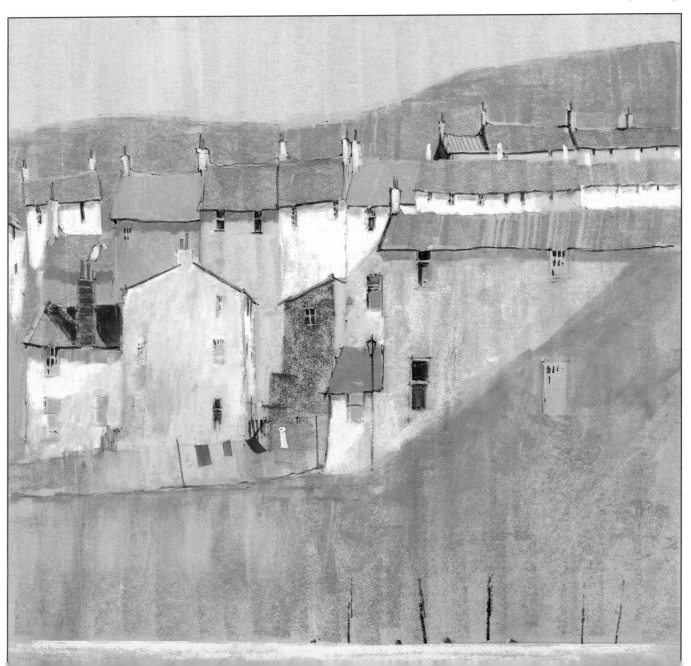

YOU WILL NEED:

Surface: Clairefontaine pastelmat paper in light grey

Tools: Faber-Castell Pitt artist pen (fine, black) or other fine, waterproof pen; 2cm (¾in) flat nylon brush; scalpel; colour shaper (size 2); coloured pencils (black; bright orange; white); mahlstick; steel nib dip pen

Pastel colours: luminous yellow; violet grey; vermilion; light grey; white; mummy; flesh ochre; Payne's grey; red brown; red light; royal blue; cinnabar green yellow; yellow lake

Acrylic colours: cadmium red; lemon yellow hue

Other: acrylic ink (white); tracing paper; scrap paper for masking

I chose a light grey surface in Clairefontaine pastelmat paper, which, though originally designed for chalk pastels, also takes oil pastel extremely well. Toned paper in a neutral colour helps to bring out the whites of the cottage fronts and make some of the brighter colours used in the painting sing. The subject is drawn out very loosely with a fibre-tipped drawing pen – it is important to make sure the ink has dried thoroughly and is waterproof; otherwise some bleeding of the lines can occur when sticks of oil pastel are applied.

1 Draw in the scene with with a fine, black waterproof, light-fast pen.

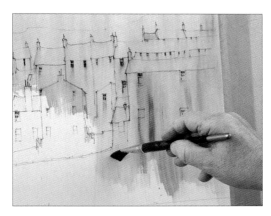

2 Mix acrylic paints in cadmium red and lemon yellow hue; using a 2cm (¾in) flat nylon brush, lay the wash in vertical strokes over the houses and the roofs, then up over the background hills. Leave the wash to dry – this may take some time as this surface is less absorbent than others.

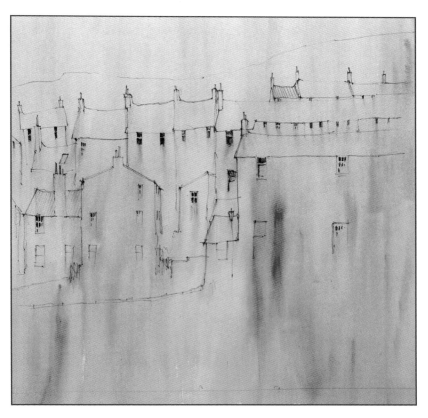

The wash and preliminary outline sketch.

3 Begin with the luminous yellow oil pastel – pull in the colour from the top of the pastelmat paper down as far as the hill line, in vertical marks. The underpainting will shine through the oil pastel layer.

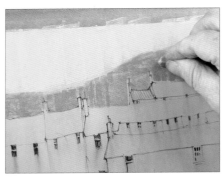

4 Push dark violet grey into the background to create the hills, still using vertical strokes from the top of the hills down, and working around the shapes of the buildings.

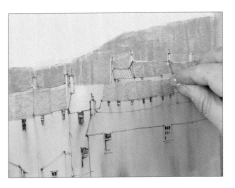

5 Fill in the bright orange pantiles on a few of the rooftops in vermilion. Keep stroking the colour downwards in vertical motions.

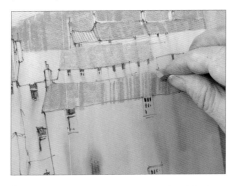

6 Following the instructions for Mark-making on page 25, use a scalpel to cut some notches into a small stub of violet grey oil pastel. Run the notched pastel down, vertically, over the roof of the foremost building. Use the same colour on the roof of the extension to the foreground building on the left.

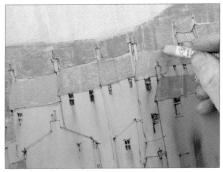

7 Switch to light grey to fill in any remaining roofs, and discern the rearmost roofs against the background hills.

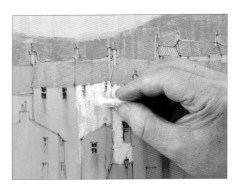

8 With the white pastel, block in the two buildings at the centre of the most prominent row of cottages, peeking out behind the foreground building. Vary the thickness of the white that you apply to each building. Shade the front of the building next to these two in light grey.

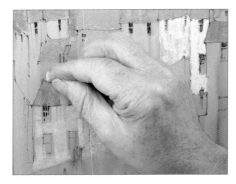

9 Use luminous yellow on the fronts of the buildings on the left of the scene, behind the tall cottage directly behind the harbour wall.

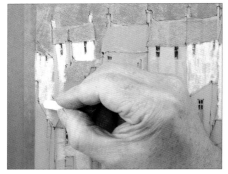

10 Block in the buildings at the very rear on the left of the scene in white pastel.

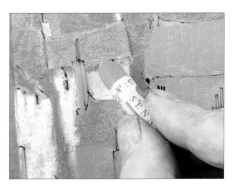

11 Bring violet grey down between the rearmost cottages, from the hills. Then run some violet grey eaves – and the shadows of eaves – along the rear row of cottages.

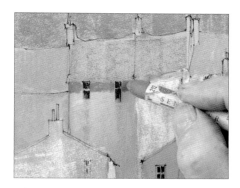

12 Use the mummy shade of oil pastel to lay in the eaves on the central light grey building.

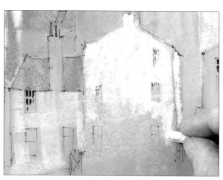

13 Pull down a light layer of white to block in the cottage in the foreground on the left – plus its extension on the very far left – then go back over to give the main cottage a gradated, whitewash effect.

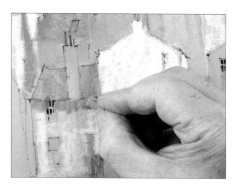

14 On the extension, put in a shadow beneath the roof in violet grey.

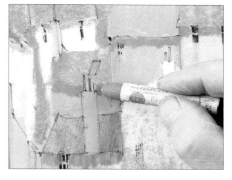

15 Use the mummy shade again to fill in the shadows of the eaves of any buildings that you have blocked in with the luminous yellow at step 9.

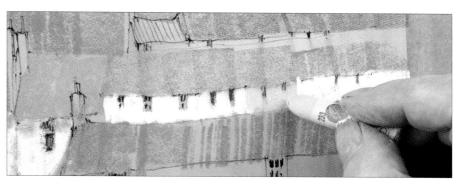

16 Move across the scene to the middle row of cottages sitting directly behind the foreground cottage. Fill in all but one in white, then swap to luminous yellow for the central cottage.

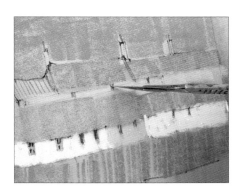

17 Use light grey to fill in the eaves of the cottages on the right at the very rear of the scene, in front of the hills. Then, using the scalpel, scrape back to the original ink lines to reveal the windows.

18 Block in the gable end of this row of cottages with Payne's grey, then blend the colour into the surface with a size 2 colour shaper.

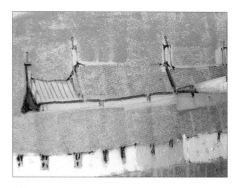

19 Use the black coloured pencil to recover some of the details of this rearmost row of cottages; use the pencil to separate the roofs, define the eaves, put shadows into the rooftops, and draw in a few extra windows.

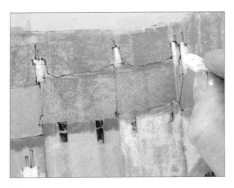

20 Go back over the orange roofs with vermilion to fill them in, then use the white pastel to fill in the chimneys.

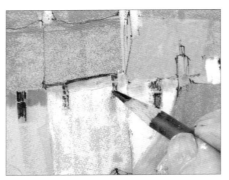

21 Use the black pencil again to draw in some eaves on the cottages in the centre of the scene in front of the hills. At the same time, define the windows and separate the roofs as at step 19.

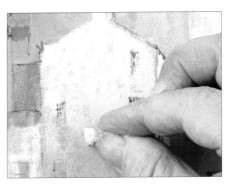

22 Sweep up into the front-left cottage with light grey, merging the colour into the white areas.

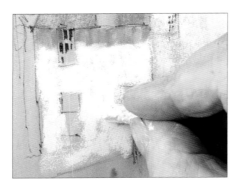

23 Add more white into the front of the extension on the left.

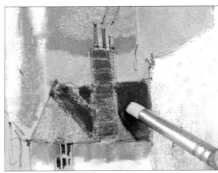

24 Working in short, horizontal strokes, colour in the large chimney on top of the extension using a red brown pastel. Fill in the cast shadow on the roof with Payne's grey, and work in the chimney pots in the same colour. Use the colour shaper to blend the colour into the surface.

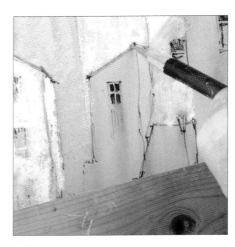

25 Using a mahlstick to protect your work, fill in the sloped roofs of the tall building in the very centre of your scene in bright-orange coloured pencil.

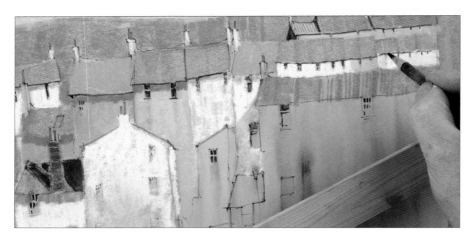

26 Switch to the black coloured pencil, and add some dark areas between the rooftops, and redefine the eaves of the right-hand buildings. Draw in some additional chimney pots here and there in the bright orange pencil.

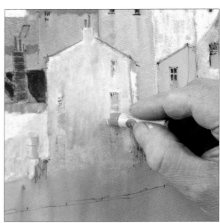

27 Fill in some more shadow on the white house in the foreground with violet grey.

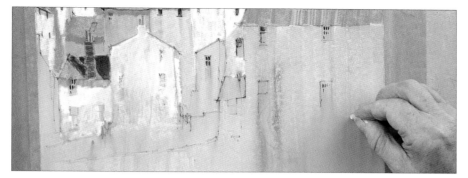
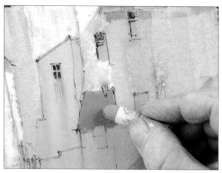

28 Make vertical strokes in light grey down the main foreground building, and down along the harbour wall in the very foreground.

29 Use the violet grey to fill in any outstanding shadows across the white buildings.

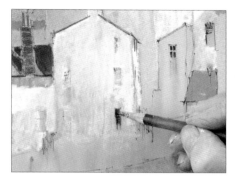
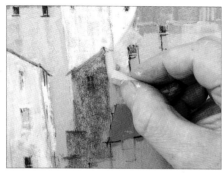
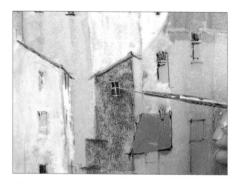

30 Redefine the roof edges with the black coloured pencil, then begin to fill in the windows of the left-hand foreground building.

31 Block in the tall, slanted building in the centre using red brown, then run a line of luminous yellow along the thin right side of the same building. Define the roof of this building with the black coloured pencil.

32 With the scalpel, scratch out some window panes on the front of the tall building.

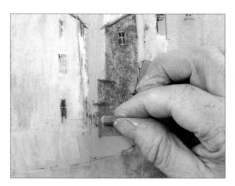
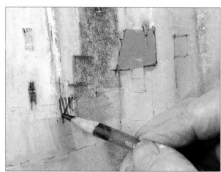
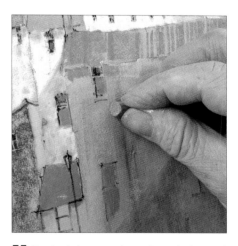

33 Working in downward vertical strokes, run violet grey down below the tall slanted building to create a separate wall.

34 Draw in a small gate with black pencil, just to the side of the violet grey wall. Add more details in black pencil in front of the tall building – a lamppost, perhaps – and redefine the windows of the extension of the large foreground building.

35 Push violet grey into the window of the extension and the large foreground building. Draw the vermilion pastel down the front of the large building, then go over the whole area with pale grey.

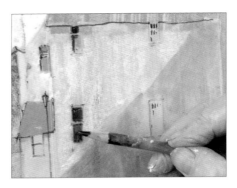

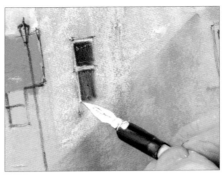

Tip
Apply the acrylic ink to places where there is no visible oil pastel: there is a risk of your painting deteriorating if any ink goes over the areas of oil pastel.

36 Work some white in over the top of the right-hand foreground building as a highlight. Redefine the eaves with the black coloured pencil. Shade in the top of the upper window; draw in the lower part of the window in an upside-down L-shape, then shade in the lower window completely in black pencil.

37 Use a steel nib dip pen with white acrylic ink to go over the window panes and ledges, and make them stand out.

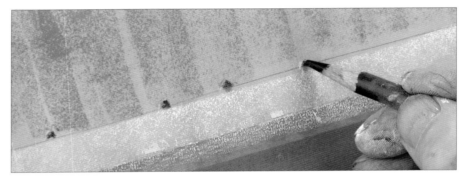

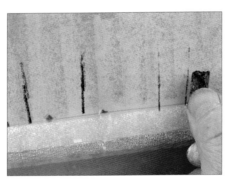

38 Run the white pastel along the very foreground in one long, horizontal stroke to create a tideline. Dot in a few buoys and floats along the side of the harbour wall in vermilion; add some highlights in white coloured pencil, and some shadow areas on the other side of each float in black pencil.

39 Hold one side of a Payne's grey pastel vertically against the surface and draw in some mooring posts at different heights along the water's edge.

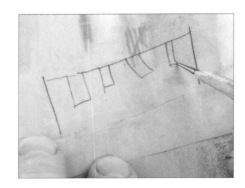

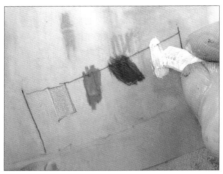

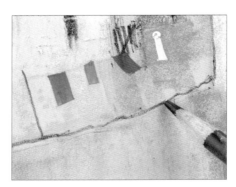

40 Use the stencilling technique shown on page 31 to create a washing line in front of the large, white left-hand cottage. Draw the washing line onto tracing paper in pencil so that the image 'ghosts' itself onto the painting.

41 Cut out the stencil shapes with a scalpel, then reposition the tracing-paper stencil over the oil pastel, and fill in laundry using the red light, white, royal blue and cinnabar green pastels.

42 Trace over the washing line with the black coloured pencil, then go over the top edge of the harbour wall to define it.

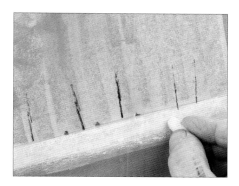

43 Run a little luminous yellow over the tideline. Then, using a straight paper edge as a mask, fill in some more white along the tideline, from left to right, to give you the water's edge.

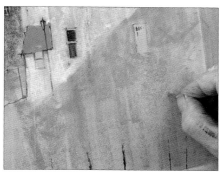

44 Go back to the right-hand building. Run violet grey along the eaves and back over the foreground in alternating vertical and diagonal strokes.

45 Blend with your finger to soften the violet.

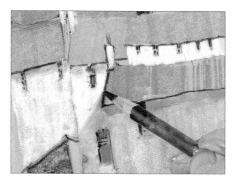

46 Fill in the chimney of the same building in the white pastel, then use the black pencil to outline the chimney.

47 Use yellow lake to suggest that lights are on in the windows of the right-hand buildings, and that the street lamp is lit. Run some yellow lake away from the doorway of the angled building to suggest the light spilling out.

48 Go back over all the eaves on the white-fronted buildings with light grey. Use the same grey pastel to define the chimneys of the furthest buildings.

49 Finally, dot a tiny skylight into the extension roof of the cottage on the far-left of the scene in the white pastel, and use the white to separate the rearmost row of cottages from the hills.

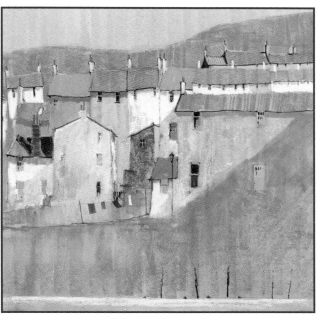

The finished painting can also be seen on page 70.

HARBOUR SCENE: 'LE FANTASQUE'

I spotted this scene while running a painting holiday in the magical light of Provence, so favoured by artists such as Henri Matisse (1869–1954), Paul Cézanne (1839–1906) and Vincent Van Gogh (1852–1890). I enjoyed the intense light and contrasts that can often be seen in this area.

The finished painting.

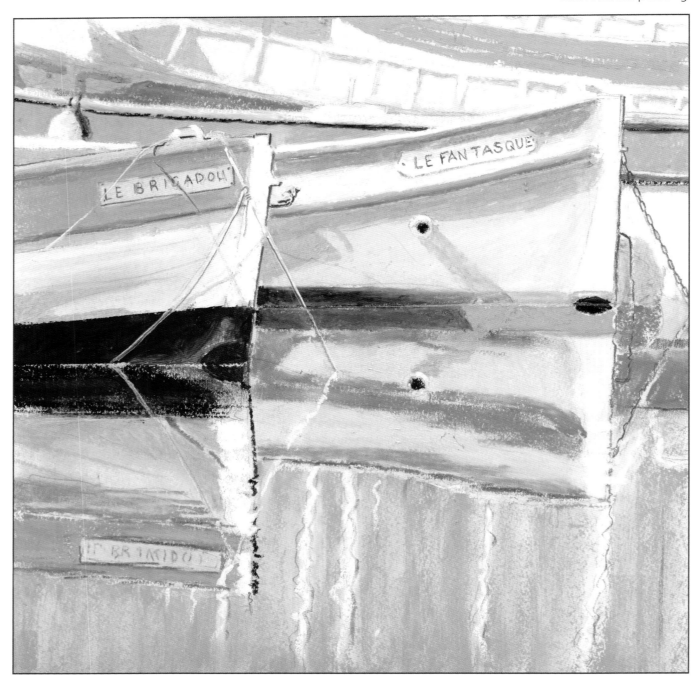

YOU WILL NEED:

Surface: line and wash board (watercolour board)

Tools: 2cm (¾in) flat brush; colour shaper (size 2); pencil; eraser; coloured pencils (indigo; steel grey; petrel grey; bright purple; mid-grey; mid-brown; brown-black; terra cotta); pro-colour pencil (white); mahlstick; penknife; steel nib dip pen; scalpel; cutting mat; wet wipes (baby wipes)

Pastel colours: white; cold grey; English grey; violet grey; red light; flesh ochre; royal blue; pale blue; Payne's grey; light grey; reddish brown grey; Chinese orange; burnt umber

Watercolours: quinacridone red; French ultramarine blue; Sennelier yellow light

Other: tracing paper; acrylic ink (white)

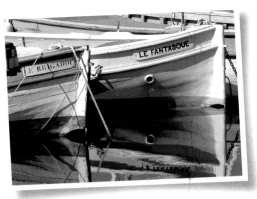

The reference photograph.

Oil pastels lend themselves well to creating the effects of shadows and water reflections. The process of painting can be sped up a little by using a more absorbent surface such as framer's mount card, which allows for layering and overlapping colours. Blending the oil pastel – with a colour shaper or a finger – generates some great, soft effects.

1 Draw in the scene with pencil first.

2 Mix quinacridone red and Sennelier yellow light watercolours and lay a wash with the red and yellow mix. Towards the bottom-right corner of the board, begin to lay in the French ultramarine blue. Allow to dry before you progress to painting with oil pastels.

Tip

Watercolour board will soak up the watercolour so you will need to work quickly to lay the wash.

79

3 Use the white pastel to outline the upper and rear edges and the insides of the boats.

4 Fill in the lower, shadowy areas of both of the central boats – *Le Brigadou* and *Le Fantasque* – in cold grey.

5 Run English grey horizontally along the top, central and lower edges of *Le Fantasque*, the right-hand boat.

6 Fill in the area around the nameplate for *Le Brigadou* (the left-hand boat) using violet grey.

7 Use a size 2 colour shaper to blend in the blue, white and violet areas on *Le Brigadou*.

8 Flick a little more white and cold grey into the base of *Le Fantasque*. Blend the colours into the bow of the boat, then go over the nameplate of *Le Fantasque* in white pastel.

9 Run light grey along the top and central edges of *Le Fantasque*. You can overlap the nameplate slightly. Work another shadow beneath the central ledge, and shape it to form the shadow of the bow of *Le Brigadou* in front. Blend the colour with your finger.

10 With a pale blue pastel, work on the boats in the upper part of the painting, putting some colour inside and along their hulls. Run red light along the top edge of the boat directly behind *Le Fantasque*.

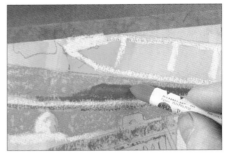

11 Fill in the same boat – behind *Le Fantasque* – in light grey, then use royal blue to fill in the tarpaulin inside the boat.

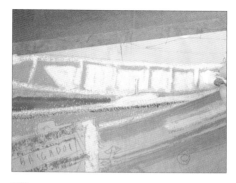

12 Run shadows in light grey – in upside-down L-shapes – alongside the white ribs inside the next boat behind. Fill in the far-left shadow in a triangle shape. Use white to fill in between the ribs, then the visible side of the boat directly behind that.

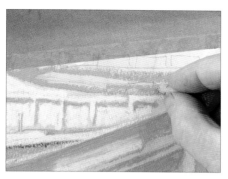

13 Outline the front edge of the next boat behind in English grey. Run the colour down into the right-hand side of the board. Repeat for the back edge of the boat.

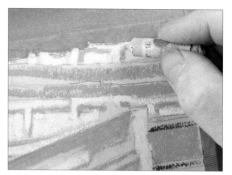

14 In white pastel, fill in the slats of the boat at the very top of the scene. Shade between the ribs in white, leaving small areas of light. Then use light grey to fill in the shadows of the ribs.

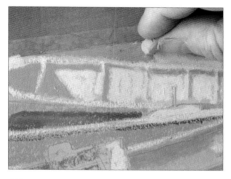

15 Fill in the tiny area between the rearmost boats at the top of the scene in flesh ochre.

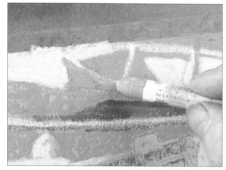

16 Fll in the visible edge of the boat in the top-left of the scene in English grey, then add a couple of strokes of royal blue over the top, and on the very inside edge of the same boat.

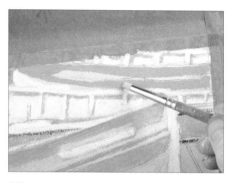

17 With the colour shaper, blend the oil pastel along the rear edge of the next boat behind, then work the colour inside the hull, into the ribs of the boat. Concentrate on blending one colour at a time; or the colour shaper will pick up different colours.

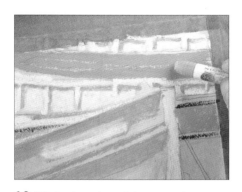

18 Fill the interior of the same boat with royal blue.

19 With the white pastel, fill in the blank area between the two boats in the top-left corner of the scene.

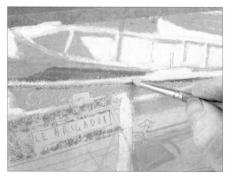

20 Move forwards to work on the boat directly behind *Le Fantasque*. With the colour shaper, blend the grey inside the hull down into the boat, then blend the red along the top edge of the boat.

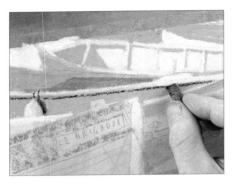

21 Soften the blue edge of the boat behind *Le Fantasque* with the colour shaper. With the white pastel, draw in a domed fender directly in front of the boat with the blue edge, and create its shadow side using Payne's grey. Soften the shadow around the dome with cold grey, then run the grey along the edge of the boat behind *Le Brigadou* as shown. Pick up the Payne's grey again, and run a line directly under the red ledge of the boat.

22 Fill in the area directly under the fender in light grey, as a shadow, then blend all the shadows – including the areas of Payne's grey – with the colour shaper.

23 Fill in the shadows on the upper part of the boat directly behind the fender in violet grey, working the shadows in as upside-down L-shapes.

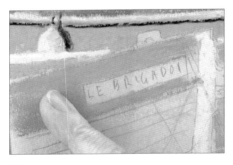

24 Sweep English grey over the violet grey already applied around the nameplate of *Le Brigadou* at step 6. Use your finger to blend the English and violet greys.

25 Run a line of violet grey as a shadow under the top edge of *Le Brigadou*, then under the ledge beneath the nameplate. Run cold grey over the nameplate itself, and use it to define a rope coming down from the top edge, securing the boat.

26 Fill in the tiny pumphole on the side of *Le Fantasque* in Payne's grey, then surround it with cold grey. Mark in a small highlight above the pumphole in white pastel, then use light grey to fill in more shadow above the pumphole.

27 Run an outline of cold grey around the nameplate of *Le Fantasque*, then push white into the areas of grey. Go over the very top edge of *Le Fantasque* with the white pastel, rotating it between your fingers to keep one edge sharp – ensure your oil pastel is sufficiently cold as you work it, as the cold helps it to maintain a sharp edge.

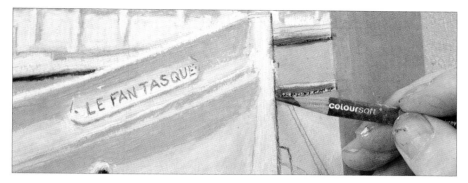

28 Write in the nameplate for *Le Fantasque* using an indigo coloured pencil. Outline the nameplate in steel grey pencil, then run a petrel-grey coloured pencil all the way along the rear edge of *Le Fantasque*.

29 For the nameplate of *Le Brigadou*, use a bright purple coloured pencil. Shape the nameplate in mid-grey pencil and dot a nail into each of its four corners. Go over the rear edge of the boat in mid-brown to refine it.

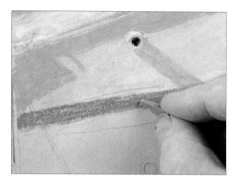

30 Use a white pencil to reinforce the back edge of *Le Fantasque*, then strengthen with white pastel. Push a little white pastel into the English grey at the base of *Le Fantasque* and blend the two colours with your finger.

31 Pull a shadow in light grey pastel from the bottom-right curve of the pumphole diagonally down to the line of turquoise at the base of the boat. Soften this shadow with your finger.

32 Run a layer of royal blue over the turquoise line – the plimsoll line.

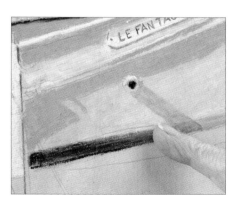

33 Go back over the plimsoll line with Payne's grey, and blend the grey into the blues with your finger.

34 Sculpt the rudder of *Le Fantasque* in Payne's grey – outline, then fill in, a semi-circle against the waterline. Soften the area of Payne's grey.

35 Fill in the visible back end of the boat directly behind *Le Fantasque* with white pastel.

36 At this point, you can use a mahlstick to protect the bottom half of the painting if you choose to. Run royal blue along the top and central ledges of *Le Fantasque*, then run pale blue on top. Run royal blue on the underside of both ledges, then blend the blues.

37 Reinforce the shadows directly beneath each ledge with light grey, then deepen with reddish brown grey on the upper and mid parts of the boat. Then push a little cold grey into the upper part of the boat around the nameplate.

38 With a scalpel, scrape away some of the excess pastel between *Le Brigadou* and *Le Fantasque*, to allow for the drawing of a chain hook.

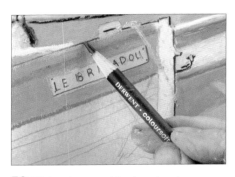

39 With a brown-black colouring pencil, go back over the front edge of *Le Brigadou* to draw in the hook for the chain. Darken the back end of the boat, then go back over the top edge with the pencil.

40 Fill in the front of *Le Brigadou* with the white pastel to cover over the original layer of violet grey. Then sweep in a little more violet grey over the top of the white, and blend both with your finger. Use the white pastel to tidy up the side of the boat.

41 Run a line of pale grey directly under the ledge of *Le Brigadou* under the nameplate. Then, further down, add some shadow in pale grey, working from the left-hand side.

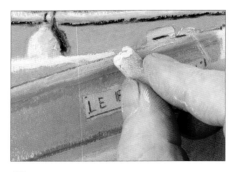

42 Go back over the very top edge of *Le Brigadou* with royal blue, then with cold grey as shown above. This helps soften and break up the original coloured pencil line. Put in a white highlight where the rope hangs over the side of the boat.

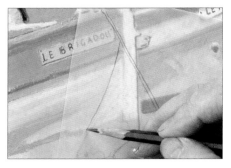

43 Following the stencilling technique on page 31, place a sheet of tracing paper over the top of *Le Brigadou*. With a soft pencil, trace in the shapes of ropes draping down from the boat. On a cutting mat, use a scalpel to cut out the shapes from the tracing paper.

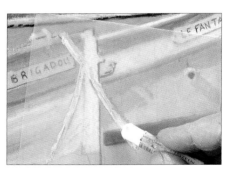

44 Work in the rope with light grey, pushing the colour through the stencil. Leave some gaps in the rope, then fill them in with white for highlights.

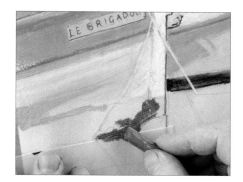

45 Fill in the bottom of the boat, closest to the water, with a small amount of Chinese orange. Use the tracing paper as a mask to achieve a straight edge against the water.

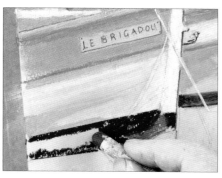

46 Work in some burnt umber all the way along the bottom of the hull, again using the tracing paper as a mask if you need to, to maintain the straight edge.

47 With a penknife, or any knife that is less sharp than a scalpel, follow the line of the rope and scratch out the burnt umber to reveal the wash beneath.

48 Dip a steel nib pen in white acrylic ink, and apply the white over the scratched-out area from step 47. Ensure you shake the bottle of ink before dipping the pen in.

49 Use the mid-grey coloured pencil to sketch in the finer details of the ropes leading away from *Le Brigadou*, including links and knots. Draw the rope leading away to the right all the way down to the water.

50 Use the same – mid-grey – pencil to draw in the chain on the rear of *Le Fantasque*, leading off to the right.

51 Use Payne's grey to work in the reflection of the small dip on the very bottom edge of the boat, then blend the colour into the surface.

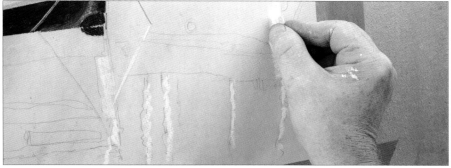

52 Lay in the reflections of unseen masts on the water with the white oil pastel. You can be a little looser when laying in these reflections – they suggest the movement of the water. Hold the pastel vertically against the board, and wiggle it downwards. Then use the white to draw in the reflection of the rope coming away from the back end of *Le Brigadou*.

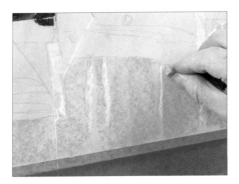

53 With the pale blue pastel, draw wide, vertical strokes down from the bottoms of each of the boats to the bottom of the scene.

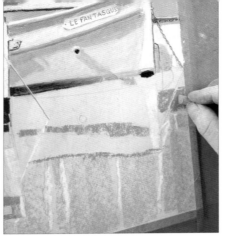

54 Go back in over the water area to lay in the reflections of the details of the boats in royal blue. When you're putting in these reflections, you do not have to use the exact colours from the scene itself – these will be altered by refraction.

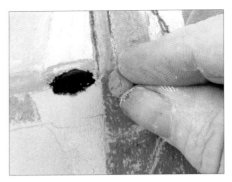

55 With the reddish brown grey oil pastel, reflect the shadow areas between the boats.

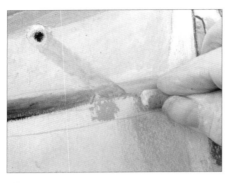

56 Reflect the very bottom edge (around the recess) of *Le Fantasque* with English grey.

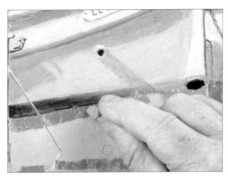

57 Reflect the hull of *Le Fantasque* with cold grey, then the plimsoll line in royal blue over the top of the grey.

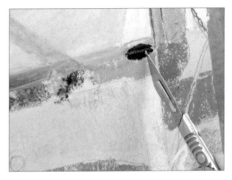

58 Run a line across the bottom edge of *Le Fantasque* in Payne's grey to reflect its shadows. Then, with a scalpel, scratch out a little area in the recess at the rear of the hull to suggest where the water lies.

59 Go back over the water area and reflect the sky in pale blue. Then, with English grey, reflect the upper edge of *Le Brigadou*, around the nameplate, into the water.

60 Draw around the reflection of the nameplate of *Le Brigadou* in mid-grey pencil – make the lines look uneven and refracted. Draw in the reflection of the name itself in a terra cotta coloured pencil, then run more cold grey over the top of the nameplate. With the mid-grey pencil, reflect the shadow of the nameplate into the water.

61 Use the burnt umber pastel to reflect the plimsoll line of *Le Brigadou* – make the colour less dense than on the boat itself to give the suggestion of reflection. Reflect the recess in the water using Chinese orange.

62 Reflect the hull of *Le Fantasque* in cold grey – pull the colour down in vertical strokes and blend with your finger.

63 Draw the reflection down from the pumphole in light grey, with burnt umber for the reflection of the hole itself. Go around the edge of the reflected pumphole with white, and use the white to reinforce the reflections of the masts.

64 Reflect the shape and the shadow of *Le Brigadou* in reddish brown grey, and use the same pastel to suggest the reflection of the upper and mid-parts of the hull of *Le Fantasque* as well, as reflected shadows. Soften all of these shadows with your finger.

65 With a scalpel, scratch away the oil pastel over the hull of *Le Brigadou* to lay in the shape of another rope coming away from the top of the boat to the left. Go over the rope with white acrylic ink using the steel nib dip pen, and reinforce the shadow with the mid-grey pencil.

66 With your finger, blend in the reflections of the boats on the hull of *Le Brigadou*. Go back over the ropes – and their reflections – in white acrylic ink with the steel nib dip pen.

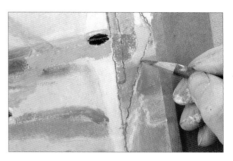

67 Use the mid-grey coloured pencil to add a little more detail to the back edge of *Le Fantasque* – including a pin coming out of the stern – then reflect the chain into the water.

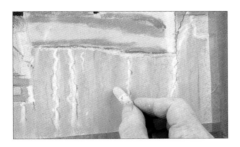

68 Follow the white reflections of the unseen masts with the mid-grey pencil. Then, with the white pastel, finish off the reflections of the top edges of each of the boats. Suggest further reflections into the water with cold grey, using light grey to darken the reflections of the hulls.

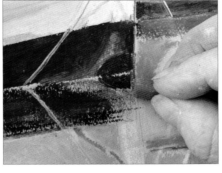

69 Run a metal bar down the back edge of *Le Brigadou* with the Chinese orange pastel, then reflect the back edge of the boat down into the water with burnt umber.

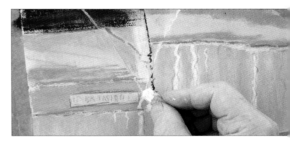

70 Go back in with white to reinforce the reflections of the ropes coming away from *Le Brigadou*, and soften the reflections of the back edges of the boats. Finally, use a colour shaper and a scalpel in turn to tidy up the plimsoll line of *Le Fantasque*.

The finished painting can be seen on page 78.

ANIMAL PORTRAITS: FREYJA

In my earlier years as an artist, I was regularly commissioned to paint animal portraits, usually in chalk pastels, and I would often use the colour of the paper surface as a background. Experimenting with oil pastel gives the artist the choice of creating something representational or, alternatively, using this expressive medium to capture the true character of the animal subject.

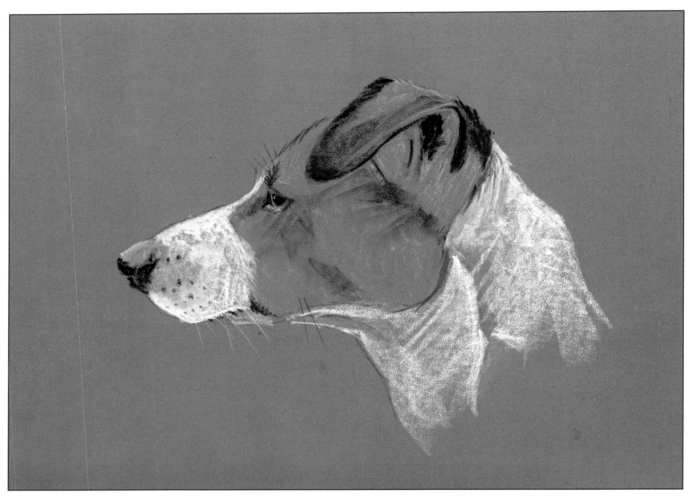

The finished painting.

YOU WILL NEED:

Surface: Clairefontaine pastelmat paper in dark grey

Tools: graphite pencil; colour shaper (size 2); mahlstick; coloured pencils (mid-grey; white)

Pastel colours: white; light English red; Payne's grey; olive brown; burnt umber; light grey; luminous yellow; yellow ochre

I caught this pose of our dog, Freyja – a Parson's Jack Russell – looking intently at something through the window, and decided that she would make a good subject for a portrait. The head is drawn in with light strokes of graphite pencil, which helps to establish a likeness before committing to oil pastel. The darker tinted pastelmat paper helps to emphasize the lighter parts of the animal, and a chilled, sharp pastel is great for capturing those finer hairs that can be stroked in towards the end of the painting process.

The reference photograph.

1 Draw the animal's head in pencil first. Begin with an outline, then add in some fine shading to give dimensionality to the animal's head, especially around the top of the head and the eyes and ears.

2 Fill in the muzzle with the white pastel. Use gentle strokes, and blend the colour so that the grey of the pastelmat paper shows through.

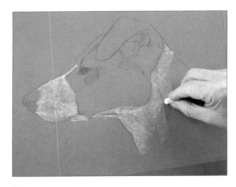

3 Fill in the chin and the neck in white, then sweep the pastel over the dog's collar area.

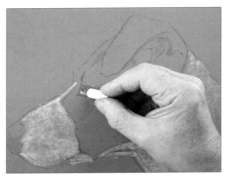

4 Fill in a small highlight in the bottom of the dog's eye.

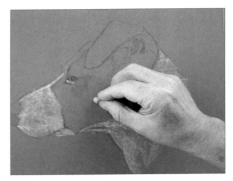

5 Shade in the dog's iris with a reddish brown grey oil pastel, then shade in the inside of her ear, round into her face, and up to the white edge of her muzzle.

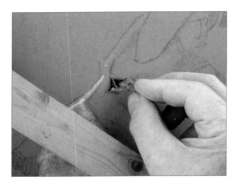

6 Fill in the pupil of the dog's eye in Payne's grey – use a mahlstick so you don't smudge the pastels you have already placed. Dot another highlight into the eye with the white pastel.

7 Work the dog's snout in Payne's grey – dot the colour in gently, from the tip of the snout back into the muzzle.

8 Outline the subtle top edge of the snout in olive brown where the snout catches the light. Push a little white into the same area.

9 Smooth the eyeball with the colour shaper.

10 Work more reddish brown grey over the top of the head, then sweep the colour back down over the dog's face. Push the colour over the top edge of the ear.

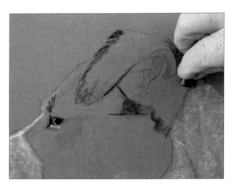

11 Darken all around the ear, the eyebrows, and the back of the dog's neck, round the back of the ear, with burnt umber. Apply the colour in short stroking motions to suggest the animal's fur.

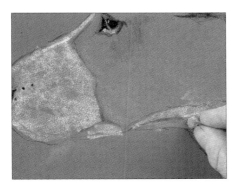

12 With the light grey pastel, work down along the neck, right behind the collar and along the dog's throat.

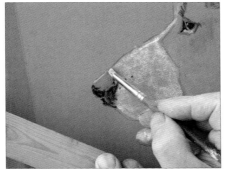

13 Put some light grey over the top edge of the snout as well, to lighten it. Blend the highlight into the snout with the size 2 colour shaper, again using the mahlstick to protect the pastel elsewhere.

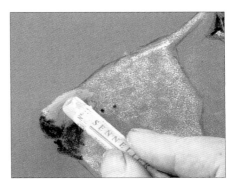

14 Sharpen the top edge of the snout with white, and repair with light grey.

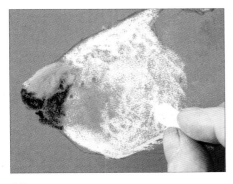

15 Strengthen the pigment on the nose with the white pastel, working around the muzzle. Then stroke in more white in a sharper curve, just above the mouth.

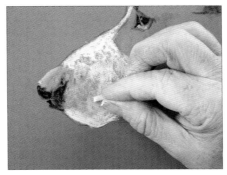

16 Stroke in luminous yellow for a pink tinge on the top of the muzzle, and along the side where the whiskers will protrude.

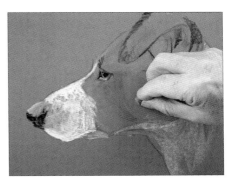

17 Sweep yellow ochre down over the side of the head where there is already colour, including over the ear.

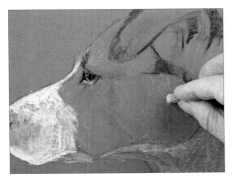

18 With the reddish brown grey, fill in any remaining gaps in the fur.

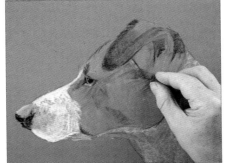

19 Use burnt umber to fill in the darker areas of the dog's fur. Define the jaw in the same colour and sweep in some darker areas coming from under the ear into the face, then back over the ear.

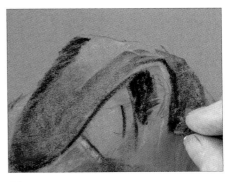

20 Work Payne's grey into the very tip, the underside and back edge of the ear nearest the collar.

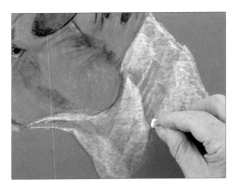

21 Reinforce some of the white areas areas around the neck and collar in diagonal strokes working from the back ridge of the neck forwards.

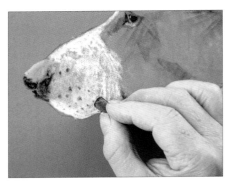

22 Add in some more dots on the dog's muzzle in Payne's grey, and work the dots along the underside, above the mouth.

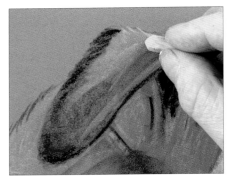

23 Stroke some more reddish brown grey back into the area under and around the edges of the ear.

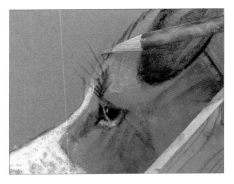

24 Draw in the dog's whiskers using a mid-grey coloured pencil – lean on the mahlstick to protect the pastel. Draw in the whiskers along the eyebrow area, then move down the jawline and draw in some whiskers here as well.

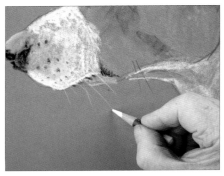

25 With a white coloured pencil, flick in some wisps coming away from the muzzle to suggest whiskers and fur.

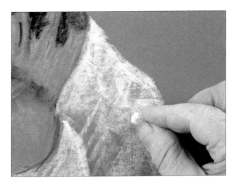

26 Go back over the back of the dog's neck with white pastel, and make short sweeps to suggest the texture of fur.

27 Put in a shadow behind the dog's ear in olive brown, then, finally, strengthen the shadow with Payne's grey. This completes the portrait.

The finished painting can also be seen on page 88.

ANIMAL PORTRAITS: VARIATIONS

Dalmatian
36.75 x 28cm (14½ x 11in)
Painted on framer's mount card.

To achieve the intense, dark background, black acrylic ink was applied around the initial drawn shape of the dalmatian's head, using a 2cm (¾in) flat brush. I corrected any overlaps by applying white oil pastel. I then used Payne's grey for the entire head apart from the eye, which was finished with pale blue and white oil pastels.

Gertrude
35.5 x 28cm (14 x 11in)
Painted on Clairefontaine light grey pastelmat paper.

CARE AND FRAMING OF YOUR ARTWORK

A finished oil pastel painting never dries completely, and this can result in damage from future handling. I store most of my work within cardboard folders interleaved with smooth glossy sheets of glassine paper to protect it – as long as the artwork does not rub against another surface during storage, the work should last indefinitely.

I frame some finished works behind glass so there is no need for me to use a fixative, but you may choose to use a fixative spray if you prefer not to frame your oil pastel paintings.

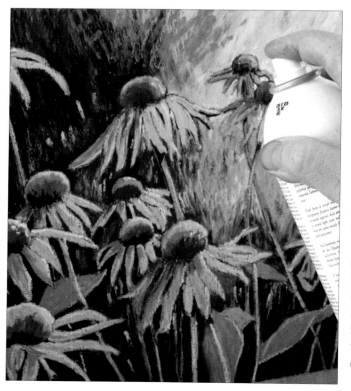

FIXING YOUR OIL PASTELS

There are instances when a fixative spray is required, such as when sending artwork through the post or when it cannot be protected by a frame – for instance, if a work is painted on a stretched canvas. The fixative must be specifically designed for use on oil pastel paintings or you risk destroying your artwork. Sennelier D'Artigny aerosol fixative is one I have always used. As a word of caution, some types of felt marker pens will run if this fixative is applied over the top of them.

The best method for applying fixative spray is to choose a well-ventilated space and to place the work upright. Spray the fixative into the open before applying it in gentle sweeping strokes over the artwork. Hold the nozzle roughly 20cm (8in) from the surface – holding the spray nozzle too close to the artwork can result in too much fixative being delivered, and surface runs can occur.

FRAMING YOUR ARTWORK

Oil pastels are best framed behind glass using an acid-free double mount and backboard. On larger paintings it may be worth considering a triple mount which is more aesthetically pleasing to the eye. The photograph on the right shows a painting framed behind a double mount – the inner mount is made from a thick mount card.

GLASSINE PAPER

Glassine is a smooth, translucent glossy paper that is air-, water- and grease-resistant. Work for presentation can be placed on a thick piece of board or oriented strand board (OSB). Glassine cut to size is placed on top and taped at the back to create a hinged folder

STORING YOUR WORK

I usually make an art folder from double wall smooth surface corrugated card, which I score down one side to make a hinge. In this I add a folded piece of glassine paper (see above) into which my artwork can be inserted. Further sheets can be added by using the same method.

INDEX